SMALL-TOWN
SLAYINGS
IN SOUTH CAROLINA

SMALL-TOWN SLAYINGS
IN SOUTH CAROLINA

RITA Y. SHULER

Charleston London

THE
History
PRESS

Although regional true crime is not often discussed as such, it comprises a huge bulk of true crime history today. Sometimes we forget how massive is the USA. Many crimes that have a strong impact on one locale can be entirely forgotten except by those to whom they most strongly mattered: the families and communities of the crime victims.

—Laura James, Crime Historian
www.laurajames.typepad.com

Published by The History Press
Charleston, SC 29403
www.historypress.net

First published 2009

Manufactured in the United States

ISBN 978.1.59629.558.2

Library of Congress Cataloging-in-Publication Data

Shuler, Rita Y.
Small-town slayings in South Carolina / Rita Y. Shuler.
p. cm.
Includes bibliographical references.
ISBN 978-1-59629-558-2
1. Murder--South Carolina--Case studies. 2. Crime--South Carolina. 3. Criminals--
South Carolina. 4. South Carolina. Law Enforcement Division. I. Title.
HV6533.S6S585 2009
364.152'309757--dc22
 2008050257

Dedicated to the memory of the innocent victims taken from us
and to the innocent victims left behind.

CONTENTS

ACKNOWLEDGEMENTS

First and foremost, my deepest thanks to my dear friend Kathleen Thornley for her support, proofreading and editing and, most of all, for always being there for me through the years.

A personal thanks to my special friend and SLED partner, Diane Bodie, for always finding time in her busy schedule to discuss our "never-ending crime stories" and share a margarita…or two.

My heartfelt appreciation to Betty Boykin, Mrs. Molly Gunter, Ricky Linett, Anthony Robinson and Eolean Fogle Hughes for sharing their loved ones' precious memories with me.

Thanks to the following, who assisted me with helpful information: Iris Mitchum; Rob Harris; Buddy Avinger; Buck Travis; Trudy Wingate; Irvin Shuler; Claire Dantzler Shuler; Kathy Riley Lowder; Becky Clement Furtick; Buddy Walling; Doug Huse; Sumter police chief Patty Patterson; Captain Mike Adams, Orangeburg Public Safety; Major Harold Carter, former Orangeburg Public Safety; Lieutenant R.C. Carter, Walterboro Police Department; Assistant Solicitor Steven H. Knight, South Carolina Fourteenth Judicial Circuit; Dr. Frank Trefney, former pathologist, Colleton Regional Hospital; Jamie Campbell, Sumter County clerk of court; Ken Bell, the *Item*, Sumter, South Carolina; and Josh Gelinas, South Carolina Department of Corrections.

Conversations with former and present SLED agents offered pertinent information about the cases and forensic information: Lieutenant Tom Darnell, Lieutenant Ira Parnell, Captain David Caldwell, Captain Ira

Jeffcoat, Special Agent David McClure, Special Agent Valerie Williams, Special Agent Dan DeFreese, Special Agent Jeff Parrott, Vick Deer, Don Girndt and Chad Caldwell.

My thanks to the following for assisting me with obtaining the investigative case files and court transcripts: Mary Perry, SLED; Melissa Winfield, Third Circuit Court reporter; and librarians Janet Meyer and Elaine Green, South Carolina Supreme Court.

I am indebted to the following local South Carolina newspapers and staff members for allowing me to use information from archived articles to fill in certain accounts, as case records were limited or missing from some agency files: Lee Harter with the *Times and Democrat*, Orangeburg, South Carolina; Craddock Morris with the *Calhoun Times*, St. Matthews, South Carolina; and Al Anderson with the *State*, Columbia, South Carolina.

My sincere appreciation and thanks to everyone at The History Press for their professional and personal assistance with the publishing of my books.

FROM THE AUTHOR

The cases chronicled in this book will forever be a part of South Carolina's history, clearly a history that we would prefer not to claim, but these cases are real and they did happen. Some segments of interviews, statements, court transcripts and published articles have been edited to facilitate reading.

Every case has its own story to tell and every crime has a victim. As special agent/forensic photographer of the South Carolina Law Enforcement Division (SLED), my work entailed *helping the victims*. My book is about *remembering the victims*. By putting the names of the ones whose lives were taken in print, they can never be forgotten or erased.

My childhood and young adult memories of how "hometown" communities were devastated by murders happening so close to home inspired me to write their stories. These same communities welcomed me back to share with me their loved ones' tales.

An unsolved case that entered my life in 1978, and never left, moved me to find the victim's family and write their story. A fifteen-year-old "cold case" that was solved with advanced forensic technology encouraged me to write that story. I trust this story will bring hope to all families of victims of unsolved cases that one day their loved one's killer will be found.

One constant ingredient of life is change. Over the years, highly advanced technology has brought many changes to law enforcement and, above all, the way the evidence is examined. New cases as well as old and cold cases can now be linked to a suspect through fingerprint and DNA databases. However, let's not forget, it still takes a human to make it work.

I write these stories with sincere compassion and respect for all concerned, but no matter how many words are written, they can never represent a complete lived experience. My passion for the victims and their loved ones will always be a part of me.

AX ASSAULT AND MURDER
OF THE STROMANS

Orangeburg, South Carolina, 1955

The Edisto River, the longest "blackwater" river in the world, runs peacefully along the edge of Orangeburg, South Carolina, winding its way down to South Carolina's coastal waters. In this "simply Southern" town, Sunday mornings are normally pretty quiet. Most residents are getting ready for church and planning what they will have for Sunday dinner.

February 27, 1955, wasn't one of those Sundays. Shocking news of what investigators would later term one of the most brutal murders and assaults in Orangeburg history spread quickly through the town and neighboring communities. Mrs. Mary Lee Stroman, seventy-five years old, was murdered, and her husband, Mr. William P. Stroman, seventy-eight years old and a veteran of the Spanish-American War, was seriously wounded. Mr. Stroman had only one leg and walked with a cane. Saturday night, February 26, 1955, as the Stromans sat quietly in their den watching television, an intruder entered their home and brutally assaulted them with an ax.

Before moving to Orangeburg, the Stromans had owned and lived on Wampee Plantation in Eutawville, South Carolina. Mrs. Stroman was born at Wampee Plantation and had inherited Wampee from her parents, Mr. and Mrs. Watts (Caroline Breeland) Bannister.

The Stromans' faithful maid of thirty years, Mrs. Patsy Brinkley, was with them during their years at Wampee. When the Stromans retired, they sold

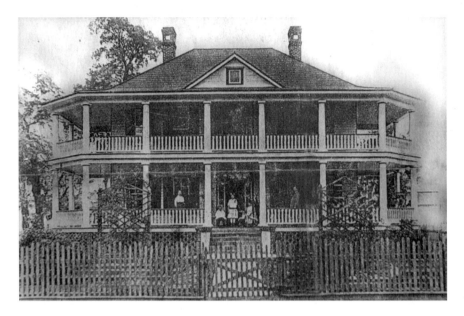

Wampee Plantation, 1915. *Photo courtesy of Buck Travis.*

Wampee Plantation and moved to Orangeburg, thirty-five miles away. Mrs. Brinkley moved with them. She resided in a garage apartment about one hundred yards behind the Stromans' Colonial-style home in a fashionable section of Orangeburg at 1017 Boulevard Northeast.

Every morning, Mrs. Brinkley, who was sixty-five years old and only had one leg, would go to the Stromans' and prepare breakfast for them and herself. On Sunday morning, February 27, about 7:30 a.m., as she was walking to the house, she saw the Stromans' little dog Bilbo outside and thought it strange because Bilbo seldom left the house without them. She walked through the porch at the back of the house to the rear door that opened into the kitchen. She only had a key to this door and carried it on a ring along with her apartment key. She always locked the kitchen door when she left in the evening. This morning she found the kitchen door unlocked. She knew that the Stromans always locked all the doors before going to bed at night. She thought this was also strange, but shrugged it off and walked into the kitchen as usual and started coffee. She put her meat on to cook and started mixing the batter cakes she would cook for breakfast. The Stromans did not open up the rest of the house, which she called "the big house," until they got up. As Mrs. Brinkley continued

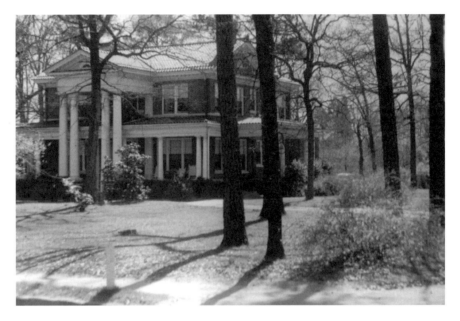

The Stromans' home on Boulevard Street in Orangeburg where the assaults occurred.

The Stromans' garage apartment behind their home where their maid, Patsy Brinkley, lived.

preparing breakfast, she heard a moan. She jerked and thought, "That sounds like Mr. Stroman. I wonder if he is sick." Then she heard Mr. Stroman call to her and went to find him. The door to the "big house" was open, too. Now she began to worry. She went through the dining area and down the hallway into the den. She found Mr. Stroman severely beaten and lying in a pool of blood on the floor near his wife's rocking chair. In the rocking chair lay Mrs. Stroman, beaten, bloody and not breathing. Shaking and scared, Mrs. Brinkley called the police.

When the police arrived at the home, they immediately called for an ambulance. Mr. Stroman was rushed to Orangeburg Regional Hospital, which was only minutes away.

Mrs. Brinkley told officers,

After I heard him call me, I went to the den and see him there on the floor. He say, "Call Marjorie." I said, "Please, sir, give me Miss Marjorie's phone number." He says, "Well I can't remember the phone number." I said, "Well I ain't know the phone number." He said, "Well call the police station." I said, "Well give me the police station number." I started crying

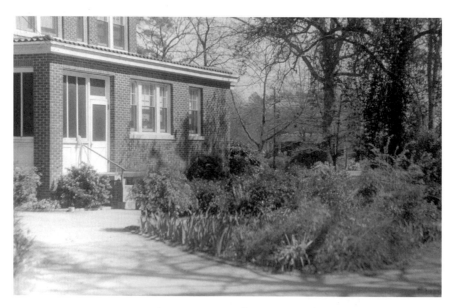

The back porch where Patsy Brinkley entered the Stromans' house every morning.

and hollered, "What is the matter with you, anyhow?" That's when I looked for the police number and called you.

The officers asked Mrs. Brinkley if Mr. Stroman had been able to tell her who attacked them.

"I said, 'Who do you like that?' He say, 'I all beat up and Mary Lee is dead.' I said, 'Well, who do you like that.' And he said, 'A nigger did it, and he had an ax. He didn't tell me what he do with the ax, just tell me he had an ax.'"

The officer asked, "He said it was a nigger. Did he tell you who the nigger was?"

"No, he never say who he is."

Officers from the Orangeburg County Sheriff's Office and the South Carolina Law Enforcement Division (SLED) joined in to assist with the investigation. They believed that the intruder had entered the home with robbery in mind because Mr. Stroman's pocketbook was missing and bureau drawers in two upstairs bedrooms had been rummaged through. He had also attempted to break into a safe in a closet near the den. The dial was broken and the door was smashed several times, most probably with the bloodstained ax that was found leaning next to the safe. In all probability this was the same ax that was used to beat Mr. Stroman and kill Mrs. Stroman. Mr. Stroman's cane lay in his chair and a bloodstained newspaper lay at the foot of his chair. They also believed that Bilbo was in the room at the time of the attack because blood was found on his collar.

Neighbors were questioned, but none of them heard any noise or disturbance in the area Saturday evening.

A motorist who was driving along Boulevard that Saturday night about 11:00 p.m. had contacted the police and informed them that he saw a Negro man stumble from the lawn in front of the Stromans' home. He said he almost hit him with his car but simply thought the man was drunk until he learned of the attack on the Stromans.

Officers talked more with Mrs. Brinkley and asked if she had heard or seen anything out of the ordinary Saturday evening. She responded,

I didn't hear anything, but I had gone to bed around ten-thirty. Earlier that Saturday night, about seven o'clock, my grandson, Junior had come to see me and stayed about ten minutes. He worked in Columbia as a

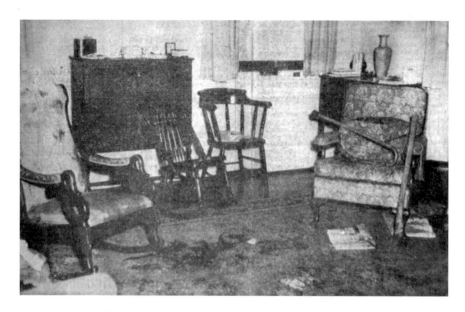

Mrs. Stroman was found in her rocking chair (left in photo). Mr. Stroman was beaten as he sat in his chair (right in photo). Mr. Stroman's cane is on his chair. The ax leaning against Mr. Stroman's chair was originally found leaning against a safe under the stairs. *Courtesy of the* Times and Democrat.

Coca-Cola drink truck helper, and he wanted some money to go back to Columbia that night on the eleven o'clock bus. I told him I did not have no money. He said he was going to borrow some from one of his friends to get back to Columbia. I tell him well, to go ahead and do so and when he needed to pay it back, I'll pay it myself. Then he left. He had come to see me on the Thursday and Friday nights before, too, and had spent both nights with me.

She told officers that Junior's name was Samuel Wright Jr. and he had grown up at Wampee. She raised him after his mama died soon after he was born. He worked sometimes as a yard boy for the Stromans after they moved to Orangeburg.

Sunday morning, February 27, about 8:00 a.m., Dr. V.W. Brabham was making his rounds at Orangeburg Hospital. One of the nurse's aides went up to him and asked if he had heard about Mr. and Mrs. Stroman. He said, "No." She said, "Mrs. Stroman was murdered last night and Mr. Stroman is in the emergency room right now." Mr. Stroman was a patient of Dr. Brabham's and the doctor knew the Stroman family well, so he went

to the emergency room to check on him. He found Mr. Stroman to be in a somewhat shocked and dazed state but not unconscious. Dr. Brabham observed two wounds above his right ear. One was about two and a half inches long and the other was a jagged, shorter wound. His face was still covered with old, dried blood.

Officers asked Dr. Brabham to view Mrs. Stroman's body, which was in the ambulance parked in the yard at the Thompson Funeral Home in Orangeburg. He finished his rounds at the hospital and went to the funeral home.

While still in the emergency room, Mr. Stroman asked the nurse to call another one of his doctors, Dr. W.O. Whetsell. He arrived and checked on Mr. Stroman's wounds also. Even in his weakened and dazed state, Mr. Stroman talked to Dr. Whetsell about what had happened to him and Mrs. Stroman. Officers also asked Dr. Whetsell to view the deceased Mrs. Stroman.

On Monday morning, Mr. Stroman was ready to talk to officers from his hospital bed and gave his account of what had happened that night. He and his wife were in their den about 10:00 or 11:00 p.m., Saturday night, February 26, watching TV. A Negro man came into the room holding an ax. He attacked Mrs. Stroman, sitting in her chair, and killed her before she could get out of her chair. He struck Mr. Stroman in his chair, knocking him unconscious. He fell to the floor near his wife's chair. He regained consciousness later on that night and crawled about twenty feet into the hall, trying to get to the telephone to call for help. He was so weak from losing so much blood that he could not make it to the phone. He crawled back into the den next to his wife's body, still in her chair. There he stayed until Mrs. Brinkley found him Sunday morning.

Lieutenant Harry Hall asked Mr. Stroman if he knew who the Negro man was who had attacked him and his wife. "Yes, it was Junior. Junior did it."

With Mrs. Brinkley's information about her grandson and hearing Mr. Stroman identify his attacker, investigators immediately focused on twenty-year-old Samuel "Junior" Wright Jr. They checked for any previous records on Wright. In January 1955, he had been questioned in connection with a string of robberies in Columbia but was released. On February 14, 1955, he was charged with disorderly conduct in Columbia and fined $25.50 or thirty days in jail by the judge in the city Recorder's Court. He paid the fine. The following week in Columbia he was put in a police lineup for liquor store and dry cleaning robberies, but none of the six was identified for the robberies.

Police also remembered an incident that the Stromans had with Wright in 1953 after he broke his grandmother's door down to get into her apartment. He was fined seventeen dollars for disturbing the peace and ordered not to go back on the grounds. As far as officers knew, he had not been back to the Stromans' until this past week.

. An alert was issued for Wright. City and county officers looked for him in the Orangeburg area while SLED agents and Columbia Police sought him in the Columbia area.

On Monday, February 28, Police Chief Salley received information that Wright, a native of Eutawville, South Carolina, was in the Eutawville area. His father and aunt lived in Eutawville. Chief Deputy B.N. Collins and City Detective Harold Hall went to Eutawville to look for Wright. Before arriving in the town, they were radioed that Wright had turned himself in to Magistrate J.U. Watts Sr. in Eutawville about 7:00 p.m., and Deputy P.T. Lancaster had picked Wright up and was transporting him to the Orangeburg County Sheriff's Office.

About 9:00 p.m. at the Orangeburg City Jail, Wright was questioned by Police Chief Salley, Sheriff Reed, Lieutenant Hall, SLED Assistant Chief J.P. Strom and Lieutenant Dollard, investigator with SLED. Several other officers were present in the room. Wright told officers, "I got to thinking when I went to visit my aunt in Eutawville on Monday and she wouldn't let me in her house 'cause she heard the police was looking for me. She say the best thing would be for me to turn myself in, so I did only 'cause I knew I was being sought and felt like it was the right thing to do."

Lieutenant Hall said to Wright, "Sammie, we want you to tell us how long you have been down this way and everything about what you've been doing."

Wright replied, "I been down here since last Tuesday looking for a job. I went to the Coca-Cola plant, the bakery, the U.S. Plywood and the employment office in Orangeburg and couldn't find no work."

"What did you do Saturday night?"

"I was at the bus station, then I went to my grandmamma's for a little bit and left and went to the White Tower and Five Points, and then to Middleton's Piccalo Joint."

"Why did you go to Mr. Stroman's house?"

"I ain't been at Mr. Stroman's house. I been at my peoples."

"Where was that?"

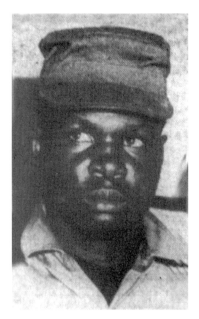

Samuel Wright Jr. after he turned himself in. *Courtesy of the* Times and Democrat.

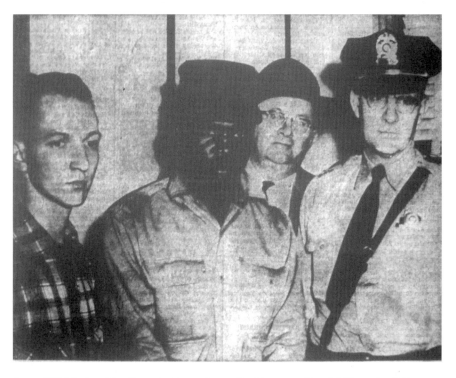

Samuel Wright Jr. with officers in Orangeburg after his arrest. *From left*: Detective E.B. Dantzler, Wright, SLED Lieutenant D.L. Dollard and Chief Deputy B.N. Collins. *Courtesy of the* Times and Democrat.

"In Eutawville."

"You remember buying a fish sandwich and a beer at Antley Lockhart's place and telling him you had plenty of money?"

"No. I ain't had no money to spend. I drank some whiskey, but I didn't buy it."

"What kind of whiskey was it?"

"Bootleg."

"Did you go to your grandmamma's when you left there?"

"I ended up there after I rode around drinking with some fellers."

"What did you do while you were at your grandmamma's?"

"We sat there and looked at television."

"When you left her house where did you go?"

"I met a boy named Jo Jr. at Five Points, and we met some other boys at Big John's Place and rode around."

Assistant Chief Strom moved in close to Wright and said, "Boy, you've been lying to us. We know what you did Saturday night and we know you're sorry about what you did, so get it off your chest and tell us the whole story."

"I ain't killed nobody. I ain't sorry 'cause I ain't done nothing. The only thing I'm sorry about is being up here."

"Sammie, you've got your poor old grandmamma on the spot. All she's done for you, I know you don't want to get her in trouble, so tell us the truth for her sake if nothing else."

"I done told you all I know."

"What did your people in Eutawville tell you when you got down there?"

"They said Mrs. Mary Lee was dead and Mr. Bill was in the hospital… that they got hit with a ax."

"Sammie, you might as well tell us all about it now. You've lied too much and it won't help you. Get it off your chest and tell us the truth. It will make you feel better inside. Now who was with you?"

Wright downed his head and said, "I done it by myself."

After over an hour of intensive questioning, Wright confessed and gave the following oral statement. Wright stated that he was at the bus station in Orangeburg on Saturday night, February 26, 1955. He said he didn't know exactly what time it was, but it was between eight and nine o'clock.

I walked to my grandmamma's house, which is in the back yard of Mr. Stroman's house. I stayed there for about thirty minutes. I ask her for the money to come to Columbia. She wouldn't give it to me and I decided to get it from Mr. Stroman. I had looked in the window of Mr. Stroman's house when I come through the yard going to my grandmamma's house and saw Mr. Stroman and Mrs. Stroman sitting in their room looking at television. I got the key out of my grandmamma's door and went over to Mr. Stroman's house. I went to the door...tried to put the key in the door. Mr. Stroman's key was in the door from the inside. I pushed my grandmamma's key in the key hole until I pushed the other key out and it fell on the floor inside the room. I went in. Mr. Stroman was sitting in a rocking chair, and Mrs. Stroman was sitting in a rocking chair looking at television. I hit Mr. Stroman with a ax. I don't remember how many times. Then I hit Mrs. Stroman. I got Mr. Stroman's pocketbook out of his pocket. I went outside, turned around and come back in the house, cut the television off and went upstairs. I pulled out some drawers and looked around upstairs, looking for money. I got some bananas and some pennies. I come back down stairs, took the ax and hit the combination of the safe twice. The safe was under the stairs. I started to put the ax back under the shed where I had got it, but I saw blood on the handle and decided not to do that. I don't remember whether I left the ax in the room or on the porch. I thought I had killed both of them. I opened the pocketbook...got around thirty or forty-five dollars out of it. I got ten dollars out of the back of it. I went cross by the over head bridge on the by-pass from Columbia to Charleston. I threw the pocketbook over in some bushes over there. There was some papers in the pocketbook, and I wadded them up and threw them down. I can show you where I threw the pocketbook. I did this by myself; no one else had anything to do with it.

This statement was made in the presence of Assistant Chief J.P. Strom and Lieutenant J.L. Dollard of the South Carolina Law Enforcement Division, Sheriff George Reed and Deputy Sheriff B.N. Collins of the Orangeburg Sheriff's Office, and Chief T.E. Salley, Chief of Detectives Harold Hall, Detective Kemmerlin and Mr. Dantzler of Orangeburg, S.C.

(Copy from SLED Case File 55-35)

Vacant lot near the Highway 601 bypass where Wright threw Mr. Stroman's pocketbook.

Wright led officers to the trash pile where he threw Mr. Stroman's pocketbook.

Officers found Mr. Stroman's pocketbook in the trash pile.

Following his confession, Wright took officers to a vacant lot about seven-tenths of a mile from the Stroman home near the Highway 601 bypass. There, officers found the pocketbook and the wadded-up papers from the pocketbook.

Wright told officers that when he left the Stromans' house the second time he walked down the driveway and across the yard to the corner of Ellis Avenue and Boulevard. He said he couldn't remember everything he did after that, but he knew that he had spent Saturday night with some people he didn't know and all day Sunday he was drunk. He spent Sunday night in a field near Orangeburg and then "thumbed" to Eutawville on Monday.

Lieutenant Hall asked Wright if Mr. and Mrs. Stroman had said anything to him when he was in the house.

"Yeah, he said, 'Yeah, nigger.' He always called me, nigger."

Later that night Wright was transported to the state penitentiary in Columbia. The next morning Wright was taken to SLED Headquarters in Columbia and repeated his confession, which was taken in shorthand by a stenographer. It was typed in duplicate and signed by Wright in the presence of a notary public and in the presence of an Orangeburg County deputy sheriff, a city police officer and two state officers, all of whom signed as witnesses. Wright also signed an appended certificate that he had read the statement and was given a copy.

STATE OF SOUTH CAROLINA
County of Richland
Personally appeared before me, Samuel Wright, Jr., colored male, who after first being duly sworn deposes and says:

I am 20 years old. I went through the six grade in school. I can read and write. I left from the bus station about quarter after seven at Orangeburg. I went up to my grandmother's house first and sat there and looked at the television. I told her I was going to Jacky Carmichael's house, but I did not go over there. I got the key out of my grandmother's door. I went and looked through the window at Mr. Stroman's. Then I went and got the ax from out of the garage. There was another key in Bill Stroman's door, so I took my grandmother's key and pushed Mr. Bill Stroman's keys out and opened the door with my grandmother's key. Then I went in the house and hit Mr. Stroman first…then Mrs. Stroman. Then I got his pocketbook, and then I come back.

After I left Mr. Stroman's house the first time, I went by the ditch bank and got the money out of the pocketbook. I throwed the pocketbook in a bush and two pieces of paper right by it…then I went to White Towers Service Station. I bought a beer and a half pint of bootleg whiskey…then I went back to the house, and I cut the television off, and Mr. Bill Stroman saw me when I cut the television off.

Then I went upstairs and looked in a couple of drawers, and I come back down, and I hit the safe twice with the ax…then I left. I hit Mr. Stroman with the ax and I hit Mrs. Stroman with the ax. It was the same ax. I got about thirty dollars out of the pocketbook. When I hit the safe with the ax, I

was trying to knock the safe open. I wanted some money from my aunt to catch the bus to come back to Columbia, and she would not give it to me, so I 'lowed [sic] to go in Mr. Stroman's house. When I went in to Mr. Stroman's, I had idea to knock Mr. Stroman in the head and get the money.

When I left the second time, I went a lot of different places. I went to the Seven Seas, to Five Points, to Pinese Milton's place, then to Shifley Quarters. The next day, on Sunday morning, I went back to Pinese Milton's place. I spent Saturday night at Sifley Quarters. I spent Sunday night in the woods.

I left Orangeburg about 12:00 o'clock Monday. I went out on 301 and to Eutawville. My aunt told me the best thing to do would be for me to turn myself in. She said someone had been there looking for me and had been to my Daddy's house.

I have been told that I did not have to make a statement, and that anything I said could be used for or against me in Court.

I make this statement of my own free will and accord, without reward or hope of reward. I have not been threatened or mistreated in any way. All of the above is the truth, the whole truth, and nothing but the truth so help me God.

(Signed) Samuel Wright, Jr.

SWORN to and subscribed to before me this First Day of March, 1955

J.P. Strom (Signed)
Notary Public for South Carolina

WITNESSES:
(Signed) B.L. Collins
(Signed) C.H. Hall
(Signed) J.L. Dollard
(Signed) J.P. Strom

THIS IS TO CERTIFY THAT I HAVE READ THE ABOVE STATEMENT AND HAVE BEEN GIVEN A COPY AS OF THIS DATE.

(Signed) Samuel Wright, Jr.

'7 99

```
STATE OF SOUTH CAROLINA,                 IN THE COURT OF GENERAL SESSIONS
COUNTY OF ORANGEBURG.

The State,                    )              O R D E R
           vs.
Samuel Wright, Jr., Defendant. )

        This matter comes on to be heard following the placing of the above named Defen-
dant in the South Carolina State Penitentiary upon a warrant charging murder.

        Since the charges are very serious, request is being made that the State Hospital
do observe the mentality of this Defendant at the South Carolina State Penitentiary so
that his mental condition will be known to this Court.  Accordingly, it us upon motion
of Julian S. Wolfe, Solicitor of the First Judicial Circuit,

        ORDERED, that pursuant to Section 32-996, Volume 3, Code of Laws of South Caro-
lina, 1952 that the said Samuel Wright,Jr., who has been placed in the South Carolina
State Penitentiary upon the charge of murder, that the authorities at the State
Hospital are hereby authorized and directed to examine the said Samuel Wright,Jr., at
the South Carolina State Penitentiary as to his mentality and to report same to this
Court as providef for by law.

        A copy of this Order will be sufficient authority for the authorities or the
Superintendent of the South Carolina State Hospital to examine this Defendant as now
confined to the State Penitentiary.

                                                    J.M. Brailsford, Jr.
DATED:  March 4, 1955                     Presiding Judge, First Judicial
                                                                    Circuit
Orangeburg, South Carolina
```

Wright's mental evaluation order. *Courtesy of South Carolina Department of History and Archives.*

On Friday, March 4, in the Court of General Sessions, Judge J.M. Brailsford, presiding judge of the First Judicial Circuit, signed the order (shown above) made by Orangeburg solicitor Julian S. Wolfe for a mental evaluation to be conducted on Samuel Wright Jr.

A report would be made within thirty days to the Orangeburg County clerk of court. On April 7, 1955, the clerk of court received the following report from William S. Hall, superintendent of the South Carolina State Hospital in Columbia.

> *In accordance with the order of Honorable J.M. Brailsford, Jr., Presiding Judge, First Judicial Circuit, COURT OF GENERAL SESSIONS, County of Orangeburg, dated March 4, 1955, I beg to submit the following report on the mental condition of Samuel Wright, Jr., who was admitted to the South Carolina State Penitentiary for psychiatric examination.*
>
> *Physical examination disclosed Samuel Wright, Jr.'s general health is good and our tests revealed no evidences of any acute or chronic physical disorder.*

Psychological examination reveals that he is functioning at an intellectual level commensurate with the average of his race, age, and educational opportunities.

Psychiatric examination does not reveal evidence of mental illness (insanity), and the medical staff diagnosed Samuel Wright, Jr. as not insane.

<div align="right">

(Signed) William S. Hall
Superintendent
South Carolina State Hospital

</div>

At the May term of the Court of General Sessions on Monday, May 2, 1955, an indictment charging the appellant, Samuel Wright Jr., with the murder of Mrs. Mary Lee Stroman was returned by the grand jury of Orangeburg County. He was also indicted on two additional charges: assault and battery with intent to kill and housebreaking and larceny. A court date was set for May 9, 1955.

The grand jury is the principal body that decides whether a person charged with a serious crime will be tried, based on the evidence presented to it by the prosecution. When the grand jury decides that a case should be tried, its finding is called a "true bill." In order to find a true bill, at least twelve of the eighteen members of the grand jury must agree that *probable cause* (a reasonable belief that a person has committed a crime) exists after evaluating the evidence and that it is more probable than not that the accused committed the wrongful act.

The following Monday, May 9, 1955, the Orangeburg County courtroom was packed for one of the most talked about murder cases in Orangeburg history. Samuel Wright Jr. was on trial for his life for murdering Mrs. Mary Lee Stroman. The *Columbia Record* reported that the courtroom was packed with several hundred persons standing along the walls, sitting in the aisles and perched on the railing of the crowded balcony, as well as occupying all available seats.

The electric chair would most certainly be on the minds of many. If Samuel Wright Jr. was found guilty of murder, the penalty could be death. In 1955, the South Carolina statute for murder was:

Section 109. (2454) Whoever is guilty of murder shall suffer the punishment of death: provided however, that in each case where the prisoner is found guilty of murder, the jury may find a special verdict recommending

(

him or her to the mercy of the Court, whereupon the punishment shall be reduced to imprisonment in the Penitentiary with hard labor during the whole lifetime of the prisoner.

(Criminal Statutes of South Carolina 1894, Volume XXI, Section 109)

First Judicial Circuit Judge J.M. Brailsford Jr. was the presiding judge. Solicitor Julian S. Wolfe would represent the state and would be assisted by the solicitor of the Fourth Judicial Circuit, Robert L. Kilgo of Darlington, South Carolina. Court-appointed attorneys, Shedrick Morgan and Newton Pough, would represent Samuel Wright Jr.

Jury selection began about 10:25 a.m. A child drew names of prospective jurors from a container and handed them to the clerk of court. It took only twenty-five minutes to seat the jury of eleven white men and one black man.

The court announced that the defendant pleaded not guilty and upon arraignment announced himself ready for trial and placed himself upon God and his country. Whereupon the jurors were sworn and charged with the trial of the case, and the murder trial of the *State v. Samuel Wright Jr.* was underway.

The defense tried to get a change of venue because of the media coverage and photographs in the newspaper alleging that all the publicity would prejudice the jurors. Judge Brailsford denied the motion.

The Stromans' maid, Patsy Brinkley, was the state's first witness. She gave her account of the Sunday morning she found Mr. and Mrs. Stroman. She broke into tears when she told how Mr. Stroman called her name and she went to him. "Mr. Stroman been on the floor laying down when he talked to me. Mrs. Stroman was on the rocking chair…laying back on the rocking chair."

After a few minutes, Solicitor Wolfe spoke gently. "Patsy, what kin is this boy, Samuel Wright Jr., to you?"

"He is my grandson."

"Now, Mum Patsy, on the night of February 26, 1955, did this colored boy, Samuel Wright Jr., come to where you live?"

"Yes, sir."

She then told the details of Wright's visit to her house the Saturday night of the murder.

Solicitor Wolfe questioned her about her key to the Stromans' house. Asked where she kept it in her apartment, she answered, "As you go into the

door you turn to the left to go in my apartment. There is a ledge on the side of the door. Sometimes I put my key there on the side."

He asked, "What did you do with your key to the Stromans' kitchen on the night of February 26, 1955, when you went home?"

"Well, you know, sir, I did not realize what place I put the key that night. I just thought I had the key up in my room. I didn't know where I put the key. But I know I had the key…come out of the house with the key and locked the back door and come on over to my house. Where I put it, I didn't know. I tote the key to my room and the back door key together."

"Now, how did you enter the back part of the house of Mr. and Mrs. Stroman on Sunday morning, February 27?"

"I met the door unlocked…so I did not know what make the door had open like that. I didn't know."

"Was it customary to lock the door?"

"Yes, sir, every night before they go to bed they lock up all the downstairs before they go to bed."

On cross-examination, Mr. Morgan asked Mrs. Brinkley what she asked Mr. Stroman when she found him beaten on Sunday morning.

"I said who do you like that? Then he say, 'A nigger and he had an ax.'"

"He said it was a nigger?"

"He said it was a nigger, but he never say who he is."

Next to take the stand was Orangeburg County Deputy P.L. Lancaster. Solicitor Kilgo asked him to tell the events that led to his finding Samuel Wright Jr. on Monday afternoon, February 28, 1955.

"Acting upon information I received on Monday morning, I went to Eutawville to look for Samuel Wright Jr. Later that afternoon, I was instructed to go to Magistrate Watts's house in Eutawville and pick up Mr. Wright and transport him back to the Orangeburg County Sheriff's Office."

"What did you do when you arrived at Magistrate Watts's home?"

"I placed Mr. Wright under arrest."

"Was the defendant sober?"

"Yes, sir."

"Was he handcuffed or locked in a building when you got there?"

"No, sir, he was on the porch and he was not handcuffed."

"And you brought him in and turned him over to the sheriff."

"Yes, sir."

On cross-examination, Deputy Lancaster was asked, "Upon apprehending Mr. Wright at the magistrate's house, did he ask you what you wanted of him?"

"No, sir, he already knew."

"Did the sheriff tell you where he got his information as to where Wright was?"

"Yes, sir. Magistrate Watts contacted Sheriff Reed and informed him that Samuel Wright Jr. had come to his house and turned himself in, and I was instructed to pick him up there and take him to the Orangeburg Sheriff's Office."

"The defendant was in the custody of the magistrate?'

"Yes, sir."

Lieutenant J.P. Strom, assistant chief of SLED, testified that he was present when Samuel Wright Jr. confessed and gave an oral statement, and he was present the next morning when Wright signed a statement at SLED headquarters in Columbia. Strom said that Wright gave the statement on his own free will. Wright's signed statement was entered into evidence. Solicitor Kilgo read Wright's statement to the jury.

Orangeburg city detective Lieutenant Harold Hall was next to take the stand. He stated that he arrived at the Stromans' residence about 8:15 a.m., February 27, 1955. He described the outlay of the house. "I went in through the back, which is a screened porch, into the kitchen, and from the kitchen to the dinette, then into a hallway and then into the den."

He stated,

> I talked to Samuel Wright Jr. when he gave an oral statement and admitted to striking Mrs. Stroman and killing her with an ax. After he told me where he threw a pocketbook belonging to Mr. Stroman, I carried him to the place on the bypass of the Columbia road, and he showed me where the pocketbook was under some vines and bushes in the vacant lot. He told us there were two pieces of paper from the pocketbook on the other side of the bush. We recovered the pocketbook, an identification card belonging to Mr. Stroman and two other pieces of paper about ten feet from where the pocketbook was found. John Whalen, a news reporter for the Times and Democrat, accompanied me to the area and made pictures of me picking up the pocketbook and papers. Afterward, Sergeant Kemmerlin of the Orangeburg Police Department took pictures of the place where the pocketbook and papers were found.

Lieutenant Hall had the pocketbook and papers from the pocketbook in his possession, and Solicitor Wolfe offered them into evidence. Defense attorney Morgan objected.

Solicitor Wolfe replied, "Council declined to admit these papers. I would like to examine the witness further."

Wolfe handed Lieutenant Hall each piece of paper and asked him what they each represented.

Hall explained, "This is a deposit slip, Southern National Bank, W.P. Stroman. This is a receipt from Omar Temple, received of W.P. Stroman."

"Who was present when these were found?"

"John Whalen, *Times and Democrat* reporter, Deputy Sheriff Collins, Samuel Wright Jr., myself and Lieutenant Strom."

"If your Honor pleases, we feel…"

Judge Brailsford replied, "I will admit them."

At this point Solicitor Wolfe handed Lieutenant Hall an instrument and asked him what it was and to describe it.

"An ax. The handle is approximately three feet long and the ax is about ten inches long by four."

"Where did you find or secure that ax?"

"On the morning of the investigation at the Stroman residence, I found it in a closet built under the stairway leaning against a safe."

"What was the condition of the ax when you examined it?"

"It had blood on it."

Solicitor Wolfe offered the ax in evidence, and there was no objection from the defense.

On-cross examination, Mr. Pough asked Lieutenant Hall, "Upon arrival at the Stroman home and being informed of what happened, did you at any time make any fingerprints or attempt to make any fingerprints?"

"I was not in charge of that."

"Did you have any fingerprints made of the pocketbook or the ax?"

"I can't testify to that."

"What officer is in charge of fingerprinting?"

"Lieutenant M.N. Cate of the South Carolina Law Enforcement Division."

"Were these items, the pocketbook and ax, turned over to him?"

"The ax was turned over to him. You can't get fingerprints off a pocketbook."

"Now, Lieutenant Hall, did you see any other type of instrument or possible weapon in the den?"

"Yes, there was…no instrument…could have been a fire iron…fire tongs rather and a shovel by the fireplace."

"Did you examine those to determine if there was any blood or spots on them?"

"Lieutenant Cate of the Law Enforcement Division will have to testify to that."

Lieutenant Cate was not called to testify.

After Lieutenant Hall's testimony, court was recessed for lunch. Court reconvened after lunch.

Doctors V.W. Brabham and W.O. Whetsell were the next two witnesses. Solicitor Wolfe asked Dr. Brabham to describe Mrs. Stroman's wounds.

"The wound was about four inches long and about three-quarters to an inch crossways. The skin and soft tissues were completely cut through. The skull bone was broken and mashed into her brain. There was blood around her head that had come from this wound."

"Doctor, did that wound in your opinion cause her death?"

"That wound, in my opinion, caused her death."

Dr. Brabham then testified to seeing Mr. Stroman. "He had two wounds on his head above his right ear. One was about two and a half inches long and the other was a more jagged wound. Mr. Stroman was in some shock… dazed but not unconscious."

On cross-examination, Mr. Morgan asked Dr. Brabham, "From your observation of the wound that you found on the head of Mrs. Stroman, would you say it was inflicted with a sharp instrument, such as an ax?"

"Yes, I would say that an ax could have produced that wound, probably not the sharp edge, probably the other edge, more likely the back side of it."

Dr. Whetsell followed with the same description as Dr. Brabham of the wounds to the Stromans. He added that when he saw Mr. Stroman in the emergency room, his face was covered with old, dried blood, and he had a smaller wound on the back of his head.

Solicitor Kilgo asked, "What is his condition as to whether or not it would be detrimental to his health to come to court today?"

"I definitely think that it would be detrimental for him to appear in court."

On cross-examination, Mr. Pough asked Dr. Whetsell, "Doctor, in your opinion, could not death have occurred prior to the infliction of the wound?"

"No, I don't think so, not the wound I saw. I would say definitely not."

"Doctor, upon your arrival to the emergency room did Mr. Stroman recognize you?"

"Yes."

"Now, would you say further that he would be able to recognize anyone that he knew quite well?"

"At the time I saw him, yes. I think he would."

Sheriff B.N. Collins and Lieutenant J.L. Dollard of SLED ended the state's testimony. Both stated that Wright was offered a chance to obtain counsel but declined, and that he signed a statement on his own free will.

After a short recess, Morgan announced that the defense would not be presenting any witnesses and it had completed its case.

In closing arguments, Solicitor Wolfe said, "We have presented honest witnesses and convincing evidence. The state has made the case beyond a reasonable doubt."

Referring to Wright's signed statement, Solicitor Kilgo spoke to the jury, "You owe a duty to the people of this community and the state to convict the defendant of murder. Let it be known to other young men in South Carolina that they cannot get away with such actions."

Mr. Pough's and Mr. Morgan's arguments included that not one state witness actually saw Wright strike the fatal blow to Mrs. Stroman with the ax.

Judge Brailsford charged the jury and instructed them of the possible verdicts they could consider: murder; murder with recommendation for mercy; and manslaughter if the evidence warrants it.

> *Murder is defined as the killing of one person by another with malice aforethought, either express or implied. Manslaughter is the unlawful killing of one person by another without malice. The absence of malice is what distinguishes manslaughter from murder. The penalty for murder is death. Should you return a verdict of murder with a recommendation for mercy, it is the duty of the court to sentence the defendant to life imprisonment with hard labor. Manslaughter is punishable by hard labor in the penitentiary not exceeding thirty years nor less than two years, at the discretion of the court.*

The jury members began their deliberations at 4:05 p.m. At 4:35 p.m. the jury returned to the courtroom. The clerk of court read the verdict. In the case of the *State v. Samuel Wright Jr.*, the verdict was "guilty of murder."

Judge Brailsford asked the defendant, "Is there anything you wish to state before sentence is passed on you?"

Wright answered, "No, sir."

Judge Brailsford sentenced Samuel Wright Jr. to suffer death by electrocution between the hours of 5:00 a.m. and 5:00 p.m. on June 17, 1955, at the state penitentiary in Columbia. His final words to Samuel Wright Jr. were, "May God have mercy on your soul."

An instant automatic appeal of a death sentence was not in effect in 1955 as it is today, but the defendant, by his attorneys, could move for an appeal during the period specified by law before his electrocution date.

The day after the trial, Tuesday, May 10, 1955, the *Times and Democrat* reported that although Samuel Wright Jr. stood before Judge Brailsford with

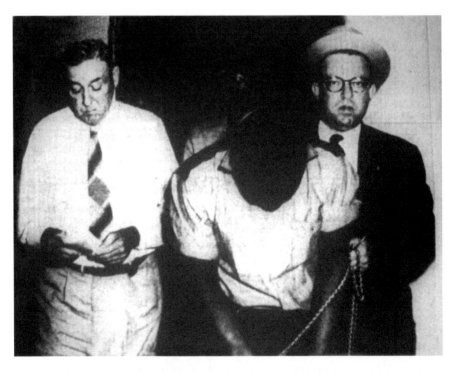

Samuel Wright Jr. being led out of the courthouse in "lead chains" after his death penalty conviction. *From left*: Sheriff George L. Reed, Wright and SLED lieutenant J.P. Strom. *Courtesy of the* Times and Democrat.

his hands on his hips showing no emotion as he was sentenced to death, he let out his feelings a few minutes later. While waiting in the sheriff's office detention room for papers to be prepared for his trip to the penitentiary, Wright, in handcuffs, picked up a small box camera from the top of a cabinet and threw it against a radiator. It almost hit one of the deputies in the room. When Wright left the sheriff's office, he was in handcuffs, leg irons and a lead chain. As Wright walked past a *Times and Democrat* photographer, he lowered his head.

On the day before Wright's electrocution date, June 17, 1955, his attorneys asked Governor George Bell Timmerman to allow them time to appeal to the state Supreme Court. Governor Bell issued the requested stay. The appeal was withdrawn when Judge Brailsford ruled that Wright had not appealed during the period specified by law. His electrocution date was set again for July 22, 1955.

On July 20, 1955, two days before Wright's electrocution date, a notice of intent to appeal was filed to the state Supreme Court on the grounds of newly discovered evidence. The newly discovered evidence was that Patsy Brinkley, grandmother of Samuel Wright Jr., had revealed that Junior had received a shot in his head; that the ball had not been removed from his head; and that since receiving the shot in the head it had affected his mind, and at intervals he had performed acts detrimental to himself and others, of which he was not conscious.

Sam Wright, Samuel Wright Jr.'s grandfather, said that to his personal knowledge Samuel Wright Jr.'s great-grandfather was insane and died at the South Carolina State Hospital in 1913. A cousin of Sam Wright, Alice Wright, was a patient at the hospital for the insane at Columbia, South Carolina, during the year 1917, and stayed for two years.

The state Supreme Court reviewed Wright's case during the December term and upheld Wright's conviction. Samuel Wright Jr.'s electrocution date was set again for Friday, January 13, 1956.

On Friday morning, January 13, 1956, the electrocution of Samuel Wright Jr. was carried out at the state penitentiary in Columbia, South Carolina.

Headlines in the *State* on Saturday, January 14, 1956, read, "Ax Murderer Wright is Dragged to Chair." An article by the Associated Press reported that Wright was huddled under blankets for more than an hour before the 7:00 a.m. electrocution time. Three ministers were in the room and sang hymns. When guards entered the cell, Wright refused to get up. Guards placed metal

Filed - 1-14-56

STATE PENITENTIARY
COLUMBIA, SOUTH CAROLINA

To_____Mr. James K. Westbury_____*Clerk of the Court of General Sessions*

of _____Orangeburg_____*County:*

We do hereby certify that____Samuel Wright, Jr._____was

duly electrocuted on__Friday____the__13__day of__January_____19**56

in accordance with law and in execution of the judgment pronounced against him at the

___May_____19**55term of the Court of General Sessions of__Orangeburg_____

County, which judgment, on appeal, was affirmed by the Supreme Court, and which

date was fixed for the electrocution by the Governor in accordance with law.

Witness our hands this the__13th.____day of__January_____19**56

W. M. Manning

Superintendent of State Penitentiary
Col. W. M. Manning

Dr. M. W. Cheatham

Physician of State Penitentiary
Dr. W. M. Cheatham

The following persons were present and acted as witnesses:

E. W. Bowell	*Aleck Frabeth*
Tom York	*Adam L. Davis*
Frank Weeks	*W B Bush*
Bennie Davis Jr	*F. J. Ulmer*
Gerald Page	*Norman T. Shuan*
D. C. Rish	*Monroe W Whetstone*

THE R. L. BRYAN CO., COLUMBIA, S. C. 165793

Execution document of Samuel Wright Jr. *Courtesy of South Carolina Department of Archives and History.*

"twisters" around his wrists and half dragged and half carried him to the execution chamber. The ministers followed behind him still singing hymns. As Wright was being strapped into the chair, he was hysterical and sobbing, "I didn't mean to kill nobody. In Jesus name, I told the truth about all I done. The Lord knows I never meant to kill nobody. Oh, Lord have mercy on me. Won't ya'll have mercy on me...please, somebody, don't let them kill me."

The mask was placed over his head. Two charges of electricity were administered. Samuel Wright Jr. was pronounced dead by a prison physician at 7:08 a.m.

Mr. Stroman died in 1957 at the Veteran's Administration Hospital in Columbia, South Carolina. He had been living at the Methodist Home for the Aging in Orangeburg since the attack and the death of his wife.

MYSTERIOUS DISAPPEARANCE AND DEATH OF AMOS BOWERS

Eutawville, South Carolina, 1955

Eutawville, South Carolina, is a small town in Orangeburg County where moss-covered trees line yards and streets with the beauty of the past and present. Eutaw Springs, on the Santee River's edge, is the site of the last important Revolutionary War battle in 1781.

About 11:30 a.m. on Sunday morning, November 20, 1955, Amos Bowers parked his car under one of these moss-covered trees in the yard of his friend Dwight West. He was never seen alive again.

Earlier that morning, Mr. Bowers had met with his tax consultant in Holly Hill, which was only a few minutes' drive from Eutawville. Bowers left some tax papers with his consultant and told him he would return in about an hour to pick them up. He never returned.

For many years, Amos Bowers and his wife, Rubie, had operated Blount's Grocery and Service Station in Eutawville and lived just a short distance away. They had recently moved from Eutawville to Santee, which is about twelve miles away, and opened up their own combination service station and grocery store. They set up living quarters above the store.

When Amos left home that Sunday, he said to Rubie, "Fix me pork chops and rice tonight for supper." He never made it back for his pork chops and rice.

When Amos had not returned home by nightfall, Rubie became concerned. She went to Deputy Sheriff Fox Hill's home just minutes away and reported her husband missing. She told Deputy Hill that a friend of

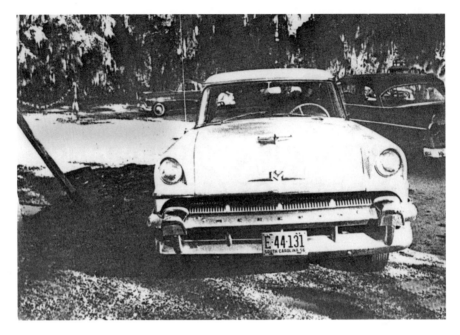

Amos Bowers's Mercury was parked in Dwight West's yard. *Courtesy of SLED.*

theirs, Perry Sweatman, had come to see him the night before. "They went outside and talked a long time, and when Amos came back inside, he wasn't acting like himself."

Orangeburg County Sheriff George Reed, Chief Deputy B.N. Collins and Deputies Fox Hill and J.D. Wactor began a search for Bowers early the next morning. Officers found Bowers's car, a late model Mercury, parked in Dwight West's yard in Eutawville. The keys were still inside. South Carolina Law Enforcement Division senior investigator M.N. Cate was called to assist with the processing of the car, including dusting for fingerprints. Nothing of value was found. The car was returned to Mrs. Bowers that afternoon.

Mrs. Bowers kept Amos's car parked in their yard. She said that Amos's dogs would lay around his car waiting for him to come home. He never made it back to his dogs.

Officers questioned Dwight West. He told them that Amos Bowers was a friend of his, and Bowers had come to his house on Sunday morning about 11:30 a.m. "He asked me if he could park his car in my yard while he went back to visit my nephew, Ril West. Ril lives in the house right behind me.

Amos Bowers. *Courtesy of Betty Boykin.*

Amos said he didn't want to take the chance of getting any scratches from limbs on his new car."

Ril West was questioned. He informed officers that Amos Bowers did not come to his house Sunday morning, and he did not see him at all that day.

The news of the mysterious disappearance of Amos Bowers ran in the Orangeburg newspaper, the *Times and Democrat*, asking anyone who might know anything or assist authorities in locating Mr. Bowers to contact the sheriff's office at the telephone number 173. Bowers was described as: white male, thirty-five to forty years of age, stocky build, approximately 170 pounds, around five feet, seven inches tall and with light sandy hair. Included in the article was a comment from Sheriff Reed: "A lot of people there think 'foul play' is involved."

For several days, concerned citizens joined officers in the search of the area where Amos Bowers was last seen, but the search proved fruitless. Chief Deputy Collins reported that there had been no new developments in the investigation, but the investigation was still ongoing. It had been almost a month since Amos Bowers disappeared.

Betty Boykin, Amos Bowers's niece, described her Uncle Amos as a humble and quiet man who would play a joke on you in a minute.

He was always fun to be around. Aunt Rubie was my mom's sister. My family lived in Connecticut for a while. Mom decided she was going to move us back to the Santee area. I stayed with Aunt Rubie and Uncle Amos for several months while Mom was packing up and getting all of her affairs in order in Connecticut to move back to Santee. Uncle Amos was like a daddy to me. He taught me how to ride a bike and how to shoot a gun. He and Aunt Rubie didn't have any children, so he spoiled me rotten. I could tell I was his favorite niece 'cause he would let me sit on his lap while he was eating and eat out of his plate. He wouldn't let anyone else do that. I love watermelon. Sometimes at night if I wanted watermelon and we didn't have any in the house, he would leave and find me some. He and Aunt Rubie loved going to the mountains, and I loved listening to his "mountain tales."

Aunt Rubie moved in with us in Santee after Uncle Amos went missing. I was so sad not knowing where he was. Then one day when I got off the school bus, a neighbor came running up to me and said, "Your uncle is

Amos Bowers and his wife, Rubie, in the mountains. *Courtesy of Betty Boykin.*

dead." I went inside and there were a lot of people there with Aunt Rubie and Mom. They told me that a bird hunter had found Uncle Amos's body in a pig pen, and he had been shot.

John Rush was quail hunting in Eutawville on Wednesday morning, December 14, 1955. Rush's sister was married to Dwight West, so he would hunt in the vicinity around their house. About 10:30 a.m., Rush and his bird dogs proceeded through the area scouting for quail. About a mile from West's yard down a small dirt road leading to fishing spots on the Santee-Cooper Lake, his dogs ran into a thicket of pine trees. Following behind them, Rush noticed them sniffing at something on the ground. As he moved in closer, he saw what appeared to be a badly decomposed body. He knew there were hogs in the area, and it appeared that the hogs had gotten to the body and torn away at the flesh. Near the body was a shredded pair of trousers, a shirt, a waist belt, shoes, a cigarette lighter and a whiskey bottle. In the pocket of the trousers was a billfold containing photos, nine dollars and personal papers of Amos Bowers. Rush notified authorities.

Above: Road leading to the spot where Amos Bowers's body was found. *Courtesy of the* Times and Democrat.

Below: John Rush points to where he found Amos Bowers's decomposed body. *Courtesy of the* Times and Democrat.

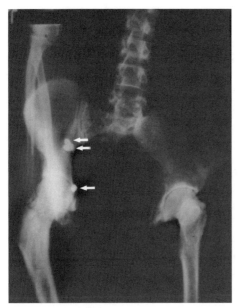 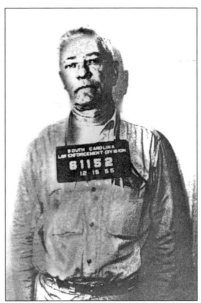

Above left: Amos Bowers's X-ray showing three pellets (arrows point to pellets). *Courtesy of Betty Boykin.*

Above right: Dwight West's arrest photo. *Courtesy of SLED.*

The body was transported to the Orangeburg Regional Hospital. X-rays revealed three shotgun pellets in the body. Autopsy reports showed the cause of death to be from shotgun blasts to the body. With those results, the Orangeburg County Sheriff's Office and the South Carolina Law Enforcement Division joined together to launch an immediate investigation again—this time into the mysterious death of thirty-three-year-old Amos Bowers.

Dwight West, the last person reported to have seen Amos Bowers alive, was the first person officers focused on in connection with what Sheriff Reed now termed as murder.

The afternoon of Thursday, December 15, SLED Assistant Chief J.P. Strom, SLED Agent Peake, Police Chief Reed and Deputy Collins went to the Savannah River Bomb Plant in Aiken, South Carolina, where West worked as a painter. West was arrested for investigation purposes and transported to the Orangeburg County Sheriff's Office. He was put through a series of questioning. Later that night, Strom and Peake transported Dwight West to the state prison in Columbia, South Carolina.

For several days West underwent intensive questioning, during which he made certain admissions. The investigations did disclose enough information for Sheriff Reed and SLED investigators to term Dwight West as Amos Bowers's killer. One development in the investigation proved that West had purchased three buckshot loads from Clark's Grocery, a short distance from Eutawville, sometime between ten and eleven o'clock on Saturday morning, November 19.

After Dwight West was arrested, rumors surfaced in the small community that Amos Bowers's body was kept in a freezer for days after the murder and later placed in the wooded area where pigs were kept. Those rumors were never officially confirmed.

Since Dwight West had not been officially charged with murder, West's attorney, F. Hall Yarborough, applied for a writ of habeas corpus (a writ requiring a court to decide the legality of a prisoner's detention) before First Circuit Judge James M. Brailsford. This would require officers to either release West or charge him with a definite offense. In lieu of this action, a coroner's inquest was set to be held at the Eutawville School the afternoon of Wednesday, December 21, 1955, to establish circumstances leading to the death of Amos Bowers.

The inquest began at 3:00 p.m. The *Times and Democrat* reported that over five hundred persons filled the room. Also present was Dwight West's attorney, Hall Yarborough, and Magistrate D. Marchant Culler. Coroner John Henry Dukes presided. Circuit Solicitor Julian Wolfe represented the state.

A six-man jury was sworn. The investigation had produced eight credible witnesses for the state. After hearing lengthy testimony from the witnesses, the coroner's jury took only twenty minutes to recommend that "Dwight West be held for further investigation and grand jury action."

Circuit Solicitor Wolfe, Magistrate Culler and Coroner Dukes held a conference after the inquest and swore out a warrant charging Dwight West with Amos Bowers's murder.

On January 3, 1956, the grand jury indicted Dwight West for the murder of Amos Bowers, and the trial was set for the May term of General Sessions Court in Orangeburg, South Carolina.

During the interval, concerned citizens of Eutawville wrote a letter to South Carolina governor George Bell Timmerman. The letter was dated March 6, 1956, and read:

Dear Governor Timmerman,
We would like very much for your office to have the killing of Mr. Amos
Bowers, on or about November 20, 1955, further investigated. We would
like to see the Constabulary check the same further or secure some detective
or investigator, as we feel such should be done.

Ten local citizens signed the petition. Among the signatures were the chief
of police of Eutawville, H.S. Dyches; Magistrate J.U. Watts; and Mayor J.H.
Marcus.

On Monday, May 7, 1956, the murder trial for Dwight West began.
Presiding was First Circuit Judge James M. Brailsford Jr. Dwight West sat
with his attorneys, F. Hall Yarborough and C. Walker Limehouse. West's
family and other relatives were beside him in the courtroom.

Circuit Solicitor Julian Wolfe read the indictment and asked West if he
was guilty or not guilty. West replied, "Not guilty."

Judge Brailsford questioned all potential jurors to make sure that each
could deliver an impartial verdict. It took only fifteen minutes for the jury to
be seated after completion of questioning.

John Rush, who found Bowers's body, was the first to testify. He told
the jury that he and his wife had been at the Wests' home on Sunday,
November 20. "I saw Dwight West around ten-thirty that morning, left
for a while and returned about 12:30 p.m. Amos Bowers's car was parked
in the yard when I returned. My wife and I left to go back to Charleston
around two or three o'clock that Sunday afternoon and Bowers's car was
still parked in West's back yard." Rush then described the area where he
found the body.

Called next was a neighbor of the Wests. She said, "On Sunday, November
20, I saw Dwight West and Amos Bowers through my kitchen window while
I was cooking dinner. It was around 11:30 and 12 noon, because I had just
gotten home from church. I only saw the two men and I didn't hear any noises
like gun shots. I learned of Amos Bowers being missing the next day."

Lee Clark, operator of Clark's Grocery, was the next state's witness. "On
Saturday, November 19, sometime between ten and eleven that morning,
Dwight West came in the store and bought three buckshot loads. Two or
three days later, Mr. West came back to the store and returned the same kind
of shells and wanted to exchange them for birdshot shells."

Solicitor Wolfe asked Clark to describe the shells returned by West.

"They were the same kind, same type and same grade including the green jackets that he had bought earlier."

The next witness was E.A. Causey from Cross, South Carolina. He relayed to the court that after hearing the news that Mr. Bowers's body had been found, he and three friends decided to visit the area on December 18. "We were familiar with the alleged crime scene location, so being curious, we went to see what we could see."

The solicitor questioned him as to what, if anything, he saw.

"One of my friends reached down and picked up a shotgun shell. Then a few minutes later we found another one."

Solicitor Wolfe asked, "And what did you do with these shells you found?"

"We went to Holly Hill and handed them over to the Holly Hill police chief, Med Baker."

J.W. Peegler, Mac Peak and N.L. Weiss followed with the same accounts as Causey describing their visit to the crime scene on December 18.

Chief Med Baker testified that on the evening of December 18, Causey, Peegler, Peak and Weiss came to the Holly Hill Police Department and turned over two shotgun shells. He then turned the discharged shells over to Orangeburg County Sheriff George Reed.

SLED Agent Peake testified about the conversation officers had with Dwight West on the trip back to the Orangeburg Sheriff's Office after West's arrest at the Savannah River Plant on December 15.

We asked him what he knew about the death of Amos Bowers and he said he didn't know who killed him. He told us they were good friends and he would never have hurt him. We asked him about him buying three shotgun shells from Clark Grocery on November 19 and he said that he bought them to go deer hunting, but he never got to go hunting so he took the shells back to Clarks and exchanged them. Later after some questioning at the Orangeburg County Sheriff's Office, Assistant Chief Strom and I took Mr. West to SLED headquarters in Columbia. Strom and I continued talking to him about Bowers. We asked if he could tell us anything about a report that Amos Bowers had been going with his wife. He said all he knew was that he had been told Bowers had a picture of his wife, but he didn't believe it. He said he even asked Bowers about it, and Bowers denied it. West told

us again that Bowers came to his house on Sunday morning, November 20 around 11:00 or 11:30 a.m. and they talked some and asked if he could park his car in his yard while he visited with Ril West that lived right behind him. He said he saw Bowers walk in the direction of Ril's house, and that was the last time he saw him. He added that if he had come back he would have given him a good beating with his fists for leaving his car in his yard all that long. On Sunday, December 18, Deputy Collins and Sheriff Reed brought two shotguns and two shotgun shells to Columbia. West identified a bolt-action shotgun as his. He said he had bought it for his son and that he hadn't hunted in years.

Dr. Will Brabham Jr. testified that he performed an autopsy on the body of Amos Bowers, and because the vital organs of the chest and abdomen were missing it was impossible to determine the cause of death. He stated that he did remove three pellets from the victim's pelvic region.

Chief Deputy Sheriff B.N. Collins was called to the stand. Questioned by the solicitor, Collins stated, "When the sheriff's office was informed about Amos Bowers being missing, we checked out every lead we could get and the investigation continued after Bowers's body was found about a mile from Dwight West's house. On the night of December 18, Sheriff Reed and I went to the Holly Hill Police Department and picked up two shotgun shells from Police Chief Med Baker. From there we went to Dwight West's home and Ril West's home."

The solicitor asked Collins what, if anything, he recovered from Dwight West's and Ril West's homes.

"After receiving the shells found at the scene and additional information from Holly Hill Police Chief Baker, Sheriff Reed and I recovered a 12-gauge bolt-action shotgun from the home of Dwight West and a double barrel 12-gauge shotgun from the home of Ril West."

"What did you do with the shotguns and shells?"

"We turned them over to SLED, the State Law Enforcement Division in Columbia. Ril West's gun was later returned to him."

The last witness for the state was Sheriff George Reed. He described the area where the body was found, adding that it looked like the body had been moved and rooted around for some fifteen feet. He relayed the same information as Deputy Collins pertaining to the shotgun shells, retrieving shotguns from Dwight and Ril West and sending the shotguns and shells to SLED.

Court was adjourned for the day.

Court reconvened Tuesday, May 8, at 9:00 a.m. The prosecution called Assistant SLED Chief J.P. Strom. Strom's testimony included much of what had been heard from Agent Peake and added, "When we went to the crime scene on December 14, we looked around the area but did not do a direct search for any shells. On Sunday night Sheriff Reed and Deputy Collins brought two shotguns and two green shells to SLED and signed them over to Firearms Identification Technician M.N. Cate for a ballistic comparison examination."

Technician Cate took the stand. He testified that he went to the home of Dwight West in Eutawville on November 20, the day Amos Bowers was reported missing. Bowers's car was parked in West's yard. "I processed Bowers's car for fingerprints and other evidence, but nothing helpful to the investigation was found."

Cate then explained the shotgun shell comparison examination. "Test shots were fired from the 12-gauge Kessler bolt-action shotgun that belonged to Dwight West. The test shells from this shotgun were compared under the comparison microscope to the shells found at the crime scene. The shells showed identical identifying characteristics in and around the firing pin indention, confirming that the two shotgun shells found at the murder scene were fired from the 12-gauge Kessler shotgun owned by Dwight West."

Cate said that he was present at the autopsy of Amos Bowers and when Bowers's entire body was X-rayed. The X-rays revealed three lead pellets in the pelvic region. He stated that the pellets weighed fifty grams, the exact weight of buckshot.

Cate also presented the articles of clothing that were recovered near the body on December 14. He said there were holes through a shirt, undershirt, underwear, waistband of trousers and a belt that were caused by shotgun discharge. There was no scorched fabric, so the shots were most probably fired from a distance.

West's attorney, Hall Yarborough, presented a motion for a directed verdict of not guilty from the court. He argued that evidence in the case was all circumstantial, and the state had not shown when, where or how Amos Bowers died or that Dwight West was the person responsible for his death.

Judge Brailsford overruled his motion and the trial proceeded. About 11:30 a.m., the state rested.

The defense began with its witnesses and called Dwight West to the stand. Attorney Limehouse asked West if he ever went hunting and if he had a

hunting license. West answered, "Yes, I hunt, and I bought a hunting license from a store in Eutawville in November because I was planning a deer hunting trip on November 20."

Limehouse asked him to show him his hunting license. West took it from his pocket. Limehouse had it admitted into evidence. The date of issue was November 19, 1955.

Asked about purchasing three buckshot shells at Clark's store on Saturday, November 19, West replied, "I did buy three buckshot shells at Clark's store, but the friend I was going hunting with got sick so I cancelled the hunting trip."

West was asked if he recognized the alleged murder weapon, the bolt-action shotgun. "Yes, I bought that for my sons, Bucky and Frankie. I kept it at my house in a bedroom closet."

When West was asked to tell what he did on Sunday, November 20, 1955, he stated,

> *I got up around eight or nine o'clock that morning. Everybody but my son Bucky had gone to church. I went to the post office and got back to the house around 11:30 in the morning. John Rush and his wife were there. John went somewhere for a while and I did some things around the house. Amos Bowers drove up about 11:30 that same morning. I went to his car and he asked if I'd like to have a drink, and I told him no. He said he was going to see Ril West, my nephew who lived right behind me, and asked if he could leave his car parked in my yard. I told him yes. He walked away and that's the last time I saw Amos Bowers.*

Several witnesses testified that they had seen and talked to Dwight West on Sunday, November 20, and Monday, November 21. They all said that he acted normal, didn't seem nervous and didn't appear out of the ordinary.

Dwight West's sons Frankie, age thirteen, and Bucky, age fourteen, were the next to testify. Frankie said that he got home from Sunday school about 11:00 or 11:15 the morning of November 20. "I went outside and was burning some trash near the chicken yard. I was sitting on a log watching the trash burn, and I heard Daddy say, 'Hello, Amos.' I didn't hear Mr. Bowers speak, and then I went off with a cousin. The next time I saw Daddy was at suppertime."

Bucky stated, "That Sunday morning I saw Mr. Bowers sitting in a car in our yard. Daddy was standing by the car talking to him. I went on in the house. In a little bit Daddy came in the house and we watched television."

When asked if he heard any loud talking between his daddy and Mr. Bowers, he replied, "No."

Limehouse asked Bucky if the bolt-action shotgun was his. "Yes, sir, I had been duck hunting last fall and I cleaned it and put it in a cabinet in the house."

Dickie West, son of Ril West, testified that he had borrowed Bucky's shotgun and hunted in the area where the body was found, and he used green shells like the ones found at the scene.

Ril West was the next witness. He said, "I was home on Sunday, November 20, 1955, and Amos Bowers did not come to my house…I didn't hear any gunshots." He also added that he had borrowed Bucky's bolt-action shotgun and used the same kind of green shells.

Martha Adams, the defendant's sister, was called by the defense. She said that she worked at a store in Eutawville, and the Wests' children got green shells from her on numerous occasions.

Evelyn Rush, wife of John Rush, the man who found the body, testified that she and her husband visited with Dwight West and his family on Sunday, November 20, but she heard no commotion and no gunshots. "I didn't see or hear Amos Bowers drive up, but I did hear one of the children say, 'Mama, Amos is here.' Dwight came in the house and we ate dinner around 12:00. He was calm as he always was. My husband and I left the Wests' home about 2:30 that afternoon."

Dorothy Vogt, daughter of Dwight West, was the last to testify. She said, "My husband and I were at Mama and Daddy's, Sunday, November 20, 1955. I was in the kitchen around 11:30 Sunday morning when I heard a car come up. I asked who it was and one of my sisters said it was Amos Bowers."

The defense rested.

The state recalled Chief Deputy Collins. The solicitor asked Collins if he had talked to Bucky West on December 19. "Yes. Sheriff Reed and SLED Assistant Chief Strom were also present. Bucky told us that he had not used the gun, had not been hunting and had not been in the area where the body was found."

The state rested. The jury left the courtroom.

Again the defense made the motion requesting a "directed not guilty" verdict, stating that the state's case was entirely circumstantial and there was no positive evidence linking the defendant solely to Bowers's death. Although it was alleged that West was the last person to see Bowers alive, and the shells found by the body were proven to have been fired from the bolt-action shotgun found at Dwight West's house, there was no way to prove that they were the exact shells that caused Amos Bowers's death or that they may have been fired in the area earlier, since the area was well known for hunting.

Solicitor Wolfe argued that there had been cases that convicted on circumstantial evidence, and the state maintained that Amos Bowers was shot on November 20, 1955, between 11:00 a.m. and 1:00 p.m., and the shooting occurred where his body was found.

After thorough consideration of evidence presented and the motion from the defense, Judge Brailsford called the jury back to the courtroom. Judge Brailsford commended Solicitor Julian Wolfe and the defendant's attorneys, F. Hall Yarborough and C. Walker Limehouse, for presenting the case in the best possible manner. He then addressed the court, stating his decision: "At this time the court directs the jury to return the following verdict, 'We find the defendant not guilty by direction of the court.'"

Dwight West was acquitted of the murder of Amos Bowers on Tuesday, May 8, 1956.

Rubie Bowers eventually moved back to Eutawville and went back to work at Blount's store. She died in 2004.

AUTHOR'S NOTE

I grew up in a rural community about fifteen miles from Eutawville. When I was ten years old, I remember my parents and neighbors talking about this case, and I read about it in the newspaper. Years later I was in high school with several of the West boys. Betty Boltin Boykin and I were classmates in high school, but I never knew she was Amos Bowers's niece until our

reconnection during my research in 2008. I remembered Betty's love for writing poetry. She shared "Uncle Amos" with me.

"Uncle Amos"
There was a man I used to know.
He loved me, and I loved him so.
He was just like my second father,
And Aunt Rubie was like a second mother.
He treated me just like his own.
I never had to be alone.
He always laughed and told a joke,
To his friends and other folks.
I was twelve the year he died.
The hurt I feel just won't subside.
I hope someday we all will know,
Who killed the man that I loved so.
Even if I never find,
The one who killed this man so kind,
God alone knows what to do,
And he won't let this killer through,
Those pearly gates to heaven's shore,
Where Uncle Amos abides forevermore.
That's where I someday hope to be.
I know someday, I'll see his face, and marvel at his awesome grace.
My Uncle Amos, my best friend.
I'll love him 'til the very end.

Written on May 7, 2008
By Betty Boltin Boykin
Niece of Amos and Rubie Bowers

KIDNAPPING AND MURDER
OF NANCY LINETT AMAKER

St. Matthews, South Carolina, 1974

Thirty-two miles south of South Carolina's capital city of Columbia is the small southern town of St. Matthews. The town sprang up after the arrival of the railroad in the area in the 1870s. The railroad still runs under "the bridges" of St. Matthews, keeping a touch of its past forever in its present.

Shortly before 6:00 p.m. on Wednesday, August 21, 1974, Nancy Linett Amaker parked her car just a short distance from the bridge and railroad tracks on West Railroad Avenue next to Savitz Department Store. Mrs. Amaker's uncle owned Savitz Department Store. She stopped by the store to pick up some dresses that her mom and dad were giving her for her upcoming twenty-ninth birthday on September 11. She entered the front door, said hello to the salespersons and proceeded to the office in the back to get her dresses. Shortly after she entered the store, a man entered the store and stopped near the front door.

After getting her dresses, Mrs. Amaker stopped at the cash register in the center of the store and purchased a pair of pantyhose. With dresses and pantyhose in hand, she headed back toward the front door. Near the front door she stopped for a few minutes to look at some children's clothes and then left.

Mrs. Teresa Walsh, an employee of Savitz, approached the man standing near the door and asked if she could help him. He didn't say anything, just turned and walked out behind Mrs. Amaker.

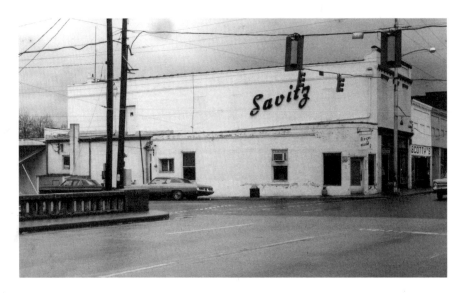

Savitz Department Store. *Courtesy of SLED.*

Mrs. Margaret Clement and her three children pulled up to the stoplight at the corner of Bridge Street (SC Highway 6) and West Railroad Avenue. They saw Nancy Amaker at the corner of Savitz Department Store. She had a green Savitz bag in one hand and clothing slung over her left arm. They knew Nancy and her family well, as they were all lifelong residents of St. Matthews.

Nancy had an eleven-year-old son, Jay, and a six-year-old daughter, Cathy. Her husband, James "Buddy," was an employee of Carolina Eastman Company near St. Matthews. Her father, Murray Linett, was a Calhoun County magistrate and owned an insurance business. She worked with her father in his insurance business. Nancy had one brother, Ricky, who also lived in St. Matthews.

Mrs. Clement's sixteen-year-old daughter, Becky, occasionally babysat for Nancy's two children and was supposed to babysit for the Amakers that same evening. Becky yelled out of the car window to Nancy, "Hey, do you still want me to babysit for you tonight?"

Nancy yelled back, "Yes, we're going to my parents' for my birthday supper tonight."

Nancy walked toward her car, a green MG that was parallel parked on West Railroad Avenue near the side of Savitz Department Store. The Clements noticed a white man walking behind her. As Nancy started to

get in her car, the man pointed a gun at her. She jerked, and he shoved her toward a yellow "Jeep-type" vehicle with a white top that was parked directly in front of Nancy's car. Nancy hesitated at the man's vehicle, but then the man shoved her into the driver's side of the vehicle and across the seat. Mrs. Clement's car windows were down, and she yelled to the man, "Is that gun real?" He yelled back, "Yes, damnit. It's loaded and get the hell out of here."

Becky said, "Mama he means it. Let's get out of here." As Mrs. Clement and her children were leaving, the man and Nancy made a u-turn on Railroad Avenue and a left on Bridge Street (SC Highway 6) toward Columbia.

Another employee of Savitz, Mrs. Ann Bolton, had also seen the man walk out behind Mrs. Amaker. From an office window at the back of the store, she saw the man and Mrs. Amaker enter the yellow "Jeep-type" vehicle that was parked on the street right outside the window. They both entered the vehicle from the driver's side. Mrs. Amaker got in and slid across the seat. The man got in behind her.

Amaker family photo. *From left*: son Jay, husband James "Buddy," Nancy and daughter Cathy. *Courtesy of Ricky Linett.*

Mrs. Clement points to the spot where the yellow "Jeep-type" vehicle was parked when she saw Nancy and a man with a gun. From the window at the back of Savitz, Ms. Bolten saw Nancy and a man enter the vehicle. *Courtesy of SLED.*

Inside the store, Mrs. Walsh was near the front windows when the yellow "Jeep-type" vehicle passed by going toward Columbia at a high rate of speed. The man she had seen in the store only minutes earlier was driving the vehicle. Nancy Amaker was in the passenger seat.

Mrs. Clement quickly headed toward her home but decided to go by the Amakers' home first. No one was home, so thinking this just couldn't be real, she went back to where Nancy's car was parked. Nancy's car was still there, but there was no sign of Nancy. It was now about 6:15 p.m. Mrs. Clement went back to her home and told her husband about the incident. Her husband called Nancy's father. Mr. Linett was fixing his famous catfish stew for Nancy's birthday party that evening and was not able to speak to Mr. Clement at that moment. Mr. and Mrs. Clement called the St. Matthews Police Department and the Calhoun County Sheriff's Office and reported the incident. Officers contacted Nancy's husband and parents and gave them the details of Nancy's possible kidnapping.

Guests arrived at the Linetts' not knowing about the incident and waited it out with the family. Nancy's brother, Ricky, was at an Elk's Club picnic at the Orangeburg Fairgrounds when he got the news.

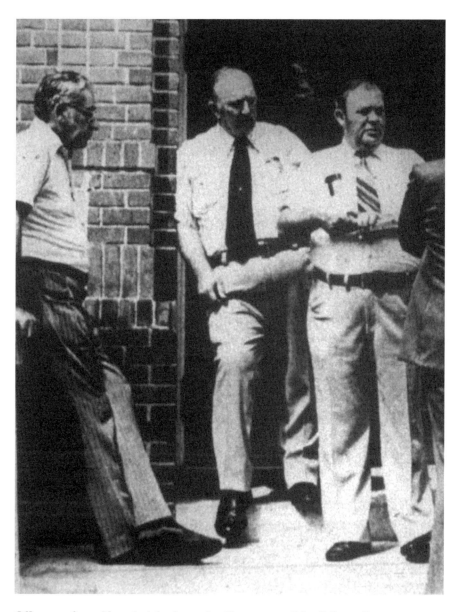

Officers confer on Nancy's abduction at the side entrance of the Calhoun County Courthouse. *From left*: Murray Linett, Nancy's father and magistrate in St. Matthews; Sheriff Elliot Rucker; and SLED agent L.C. (Jack) Kemmerlin. *Courtesy of the* Times and Democrat.

The last known contact Mrs. Amaker had with her family was a phone conversation with her mother about 5:30 p.m. telling her she was on her way to pick up the two dresses from Savitz.

At this time, it was alleged that Mrs. Amaker left under force. Calhoun County Sheriff Elliott Rucker requested that the South Carolina Law Enforcement Division (SLED) assist in the investigation of the possible kidnapping of Nancy Amaker.

All witnesses described the man that they saw as a white male, thirty to thirty-five years old, six feet tall, husky-rugged build, about 190 pounds, coarse, bushy regular cut light brown hair and tan complexion. He wore a medallion on a gold chain around his neck.

Shortly after Sheriff Rucker contacted SLED, a call came into SLED headquarters from the South Carolina Highway Patrol reporting that a Mrs. Easterling had her automobile shot at while en route from Orangeburg to her home in Lexington, South Carolina.

SLED Agents Jack Kemmerlin and Sidney Taylor met with Mrs. Easterling. She told officers that about 5:30 p.m. on Wednesday, August 21, 1974, she left her place of employment at Kirkland Laundry in Orangeburg, South Carolina, going to her home in Lexington, South Carolina, by way of Highway 601 and Interstate 26. As she left SC Highway 601 and turned onto I-26 toward Columbia, she saw a dirty blond white male standing behind a yellow vehicle on the side of the road. He appeared to be sick, and he started waving as if to flag her down to help him. She did not stop and continued toward Columbia on I-26. Shortly after passing the yellow vehicle, she looked in her rearview mirror and saw the yellow vehicle pulling up behind her. The vehicle was weaving in the road. She pulled over to the right lane, and the man in the yellow vehicle pulled up beside her in the left lane and appeared to adjust his speed to hers. He continued to stay alongside her in the left lane. When she slowed down or speeded up, he slowed down or speeded up. At one time when she looked over at him, he pointed what looked like a gun and fired. She ducked down in her car and when she raised back up he fired another shot at her. At this point she speeded up as fast as she could drive, turned on the car's flashers and started blowing the horn. She was able to overtake another vehicle and she waved to the driver to stop. The other vehicle stopped and she told the driver, Mr. Silvey, a traveling salesman who lived in Columbia, what had happened.

He followed Mrs. Easterling to her home in Lexington. She immediately reported the incident to the South Carolina Highway Patrol.

Mr. Silvey was interviewed by telephone by Captain Leon Gasque with SLED. He informed Captain Gasque that he had also seen a yellow vehicle parked near the intersection of Highway 601 and I-26 with a white male standing behind the vehicle when he passed the area just ahead of Mrs. Easterling. He advised that the vehicle was a Ford Bronco, yellow with a white top and white sidewall tires and South Carolina license plates. He did not get a license number. After Mrs. Easterling stopped him, he saw the same yellow Ford Bronco make a u-turn across the median and leave I-26 on SC Highway 6.

Captain Gasque noted that St. Matthews was approximately seven miles from the intersection of Highway 6 and I-26, and about thirty minutes after the yellow Bronco left I-26, Mrs. Amaker was taken by gunpoint in St. Matthews by a man driving what was described by witnesses as a yellow "Jeep-type" vehicle.

SLED Agents Jim Springs and Ira Parnell processed Mrs. Easterling's blue Cutlass Oldsmobile and removed a .38-caliber bullet from the car.

Blue Cutlass Oldsmobile that was shot at on Interstate 26. A .38-caliber bullet entered the left rear roof section. *Courtesy of SLED.*

On Thursday morning, August 22, Mr. Carol Horton, a pharmacist in St. Matthews who lived on Doodle Hill Road just a short distance outside of St. Matthews, contacted law enforcement officials and informed them that he had heard the news about Mrs. Amaker's alleged kidnapping, along with the description of the alleged kidnapper and vehicle, and he had seen the vehicle with two occupants the day before. He told investigators,

> *Sometime around 6:15 p.m. on Wednesday, I stopped at a stop sign at the intersection of Doodle Hill Road and U.S. Highway 176. A vehicle pulled up and stopped behind me. After the traffic cleared, I turned right onto Highway 176 toward Columbia. Immediately the vehicle behind me did likewise. At that time, the vehicle, which was a "Bronco type," yellow with a white top, passed me at a high rate of speed headed toward Columbia. Because of the way the vehicle was being driven, I looked at the license tag. On the bracket around it, I remembered seeing the letters M-E-R, and possibly, a T, and it might have been a T-S. I took it to be maybe Merritt or something similar. I was not positive of all the letters that were on it, but the letters were on the metal bracket around the license plate. I didn't remember the license number. I also remember seeing FORD on the vehicle. At first I saw only the driver, but as he passed me, I saw the head of another person rise up from the seat, but he passed so fast that I couldn't tell if it was a male or female.*

Mr. Horton said that he had continued on to Columbia, and about fifteen miles after the Bronco passed him, he saw the Bronco around the intersection of Highway 176 and I-26 but didn't get close enough to observe any further details.

Investigators, which now included the FBI, immediately began working with Mr. Horton's information, checking out all auto dealerships in South Carolina for the letters M-E-R__T-S in its title. Later Thursday afternoon, August 22, investigators made contact with Merritt Motors in Beaufort, South Carolina. Documentation showed that Jack Steele of Hardeeville, South Carolina, purchased a 1974 Ford Bronco, white over yellow, two-door, on July 16, 1974, for $5,000 cash.

A picture of Jack Steele was obtained through the South Carolina Highway Department. Conversations were held with several acquaintances of Jack Steele. They all said that he resided in Jasper County, near the community of

Hardeeville, South Carolina. A photo array was shown to Mrs. Easterling and other witnesses who had seen the man with Mrs. Amaker in St. Matthews. They all selected the photo of Jack Steele.

Investigators went to Jack Steele's residence in Hardeeville on Thursday afternoon, August 22, and spoke to his wife, Joy. She told officers that her husband, Jack Steele, did have a yellow-and-white Ford Bronco. He was unemployed, and he had left home about 1:00 p.m. on Wednesday, August 21, in the Bronco to go to Hilton Head Island, South Carolina, Savannah, Georgia, and Atlanta, Georgia, looking for a job. She said, "Jack had been depressed and had been drinking a lot the morning he left. He played for a while with our two children then took a shower, dressed and left. I have not seen him since he left the morning of August 21."

She admitted that his true name was Jack Leland Allen, and he was a fugitive from the state of Michigan. He had been arrested in the past for armed robbery, kidnapping and car theft. She noticed that two rifles were missing from the house. When asked if he wore a chain and metal around his neck, she replied, "He always had a gold St. Christopher's metal on a chain around his neck."

Jack Allen, aka Jack Steele, was driving a 1974 yellow-and-white Ford Bronco like the one in this photo. *Courtesy of the Doug Huse Bronco Collection.*

Descriptions and photos of Nancy Amaker and Jack Leland Allen were locally and nationally circulated. *Courtesy of the* Times and Democrat.

With this information, Sheriff Rucker signed a warrant for the crime of kidnapping for Jack Leland Allen, aka Jack Steele. A state and national alert was issued. Descriptions of Mrs. Amaker, Jack Leland Allen and the yellow Ford Bronco were put out through local newspapers, county radios, the state teletype system and the Lett system, which is a national teletype system. Coverage in the *Times and Democrat* quoted Sheriff Rucker as saying, "The vehicle is like searching for a big yellow Easter egg! It seems impossible it could be missed."

SLED's airplane began an air search of surrounding areas. The residence of Mrs. Jack Steele was put under surveillance by agents of the South Carolina Law Enforcement Division in the event that Allen/Steele would return to his home.

On Thursday, August 22, in Darlington County the weather was fair and warm. About four o'clock that afternoon, Dargan Isgett took his two nephews fishing at Back Swamp Bridge located about a mile and a half off Interstate 95 on South Carolina Road 327. He parked his station wagon on the left side of the road near the bridge because there

Above: The Darlington/Florence County line runs down the middle of Black Swamp Bridge. *Courtesy of SLED.*

Left: Nancy's body was in the edge of the bushes and briars where Mr. Isgett parked his car. *Courtesy of SLED.*

was not enough room on the right side to get both wheels off the road. He and his nephews got out of the car, got their fishing poles, bait and tackle and fished for about an hour and a half. When they were leaving, the boys got in on the road side of the car and Mr. Isgett went around to the back of his station wagon and put the poles and tackle box in the car. As he went around the back corner of the station wagon on the driver's side, over in the edge of the bushes and briars he saw the nude body of a white female. He walked down to get a closer look and found that she was not breathing.

Mr. Isgett knew Deputy Coker O'Neal with the Darlington County Sheriff's Department. Deputy O'Neal lived only three or four miles from the bridge, so Mr. Isgget went and got the deputy and took him back to where the body was.

The Darlington/Florence County line ran down the middle of the bridge. The body was off the shoulder of the road on the Darlington County side of the bridge.

It was about 5:50 p.m. Deputy O'Neal notified local authorities. With the statewide teletype information of the kidnapping and intensive search

Nancy's body was found approximately forty feet from the edge of the bridge and off the shoulder of Road 327 in Darlington County. *Courtesy of SLED.*

for Nancy Amaker, the Darlington County Sheriff's Department contacted Sheriff Elliott Rucker in St. Matthews and informed him that the body of a white female matching the description of Mrs. Amaker had been found about eighty-five miles from St. Matthews near the Darlington/Florence County line.

The body was transported to a local hospital. Officers contacted Mrs. Amaker's husband. They informed him of the discovery of a body that matched the description of his wife and told him they would need him to view the body and make a positive identification. As he entered the morgue and saw Nancy's body, he was so shocked that he collapsed.

The following day, Friday, August 23, Dr. Sandra Conradi, forensic pathologist with the Medical University of South Carolina in Charleston, performed the autopsy. She estimated Mrs. Amaker's death some thirty-six to forty-eight hours before she saw the body, probably sometime around 12:00 a.m. on Thursday, August 22. Dr. Conradi reported numerous scratches and bruises on the body, pointing out a rather long scratch on the inner aspect of the right arm that was associated with a bruise. No other scratches were associated with a bruise. The fatal injury was a hard contact gunshot wound to the back of the head, meaning that the gun was held tightly against the head when the shooting occurred. From her examination of the wound and additional body findings, she suggested that death had occurred probably in the range of five minutes after the wound was inflicted. There was no exit wound of the bullet from the head, confirming that the bullet stayed within the skull along its path. Only fragments of the bullets were found in the skull, indicating that the bullet had torn apart within the skull. Dr. Conradi removed eight bullet fragments from the head and collected hair samples and right and left fingernail scrapings from the victim. She delivered the fragments and samples to the SLED Laboratory.

SLED firearms examiner Dan DeFreese examined the bullet fragments and reported that they were too badly damaged for positive identification with any particular weapon.

Sheriff Elliott Rucker issued a warrant charging Jack Leland Allen with murder.

Word of the discovery of Mrs. Amaker's body spread quickly in the town of St. Matthews. "County Is in Shock Over Abduction and Slaying of Nancy Linett Amaker" was the front-page headline of the town's newspaper, the *Calhoun Times*.

SMALL-TOWN SLAYINGS IN SOUTH CAROLINA

Joyce W. Milkie, reporter for the *Times and Democrat* of Orangeburg, shared comments from St. Matthews residents in her article, "St. Matthews People Stunned":

> *An unbelievable crime occurred in this Calhoun County community Wednesday afternoon, and the citizens are still stunned, frightened and reacting to the violence that came to them with the kidnapping and murder of a young matron, Mrs. James (Nancy Linett) Amaker.*
>
> *Calhoun County Sheriff Elliott Rucker said that the townspeople were certainly nervous and upset at the bizarre and seemingly motiveless crime that took the life of the twenty-eight-year-old mother of two.*
>
> *"The whole community is all upset and stunned", said John G. Felder, St. Matthews attorney and candidate for the S.C. House of Representatives. "I have known Nancy all my life, and I know her husband. They are fine people. It is inconceivable that such a thing could happen in this town. We are all so very sorry."*
>
> *"A lot of people are wondering why it would happen here...in a small town like this. This is the kind of thing you hear happening in a big city, but not here."*
>
> *"I've known her since she was a little kid, and I've known her family. It just doesn't seem possible."*
>
> *"This is the worst thing ever to happen in this town. We feel so sorry for the family."*
>
> *"It's unreal! The town is very uptight about the whole thing."*

Investigation soon revealed that Allen had lengthy criminal records outside of South Carolina, was presently wanted in Grand Rapids, Michigan, on numerous counts and was a parole violator from the Michigan Department of Corrections.

The South Carolina Law Enforcement Division and the State of South Carolina, through its general fund, offered a $1,000 reward for any information leading to the arrest and conviction of Jack Allen.

The SLED Record Section prepared, mailed and distributed wanted flyers on Allen. Flyers were distributed to all police and sheriff's departments in South Carolina, the Columbia FBI, all State Identification Bureaus nationwide and all departments in Georgia and Florida. Flyer information was relayed to South Carolina radio and TV stations and air flights.

Mr. and Mrs. Linett and baby Nancy. *Courtesy of Ricky Linett.*

A family friend holding Nancy on Main Street, St. Matthews, 1946. *Courtesy of Ricky Linett.*

As a result of the extensive distribution and media coverage of information, contacts were made with SLED Headquarters and noted by SLED's Record Section as follows:

August 24, 1974: Chief of police of St. George, South Carolina, advised Captain Gasque that the man suspected in the abduction of Nancy Amaker purchased a diamond ring at a jewelry store in St. George about 3:00 p.m. on August 21, 1974. He wrote a check at a Hilton Head bank and paid the fifty dollars tax in cash. He appeared to be intoxicated.

August 24, 1974: Deputy Sheriff Karr of the Beaufort County Sheriff's Office advised Captain Gasque that Jack Steele bought three guns at L.L. Gun Shop in Beaufort, South Carolina, on June 21, 1974.

August 25, 1974: Sheriff Ralph Tyson of Greenville, North Carolina, contacted Captain Gasque, FBI Agent Bill Danielson and St. Matthews Sheriff Rucker and advised them that the yellow Bronco had been located at a used car lot at Hastings Motors in Greenville, North Carolina.

At the same time, the FBI in North Carolina contacted Captain Gasque and informed him that between 2:30 a.m. and 3:00 a.m. on Thursday, August 22, 1974, Steele was in Greenville, North Carolina, and placed a

telephone call to his wife. Between 9:30 a.m. and 11:30 a.m. on that same day, Steele attempted to sell the yellow Bronco to Hastings Ford Company. William McClure, vice-president of Hastings Ford, called Merritt Motors in Beaufort, South Carolina, to determine if the Bronco had a lien and received information that the vehicle was clear of liens. Hastings Motors paid Steele $3,500 for the vehicle.

FBI agents, SLED agents, officers with the St. Matthews Sheriff's Office and Mr. Bowers with Merritt Motors in Beaufort, South Carolina, traveled to Hastings Motors in Greenville, North Carolina. Mr. Bowers confirmed that the yellow Bronco was the same vehicle that he had sold to Jack Steele in July 1974. Mr. McClure at Hastings Ford informed the agents that Steele had given one of his salesmen a black nylon rope, an army shovel, a machete and a pair of black rubber boots that were in the Bronco. FBI Agent Danielson took possession of these articles. McClure said that he had taken Steele to the bank to cash the check for the sale of the Bronco.

Agents asked Mr. McClure if he noticed any stains or anything of that nature inside the Bronco. He replied, "Mr. Steele pointed to bloodstains above the right sun visor in the vehicle, the one on the passenger side, saying that he was a hunter and they were deer bloodstains."

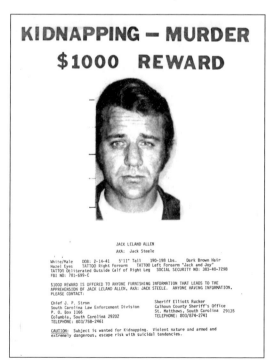

Wanted flyer. *Courtesy of SLED.*

Other information confirmed that on Thursday, August 22, 1974, Jack Steele had registered at the Holiday Inn in Greenville, North Carolina, and rented a 1974 Monte Carlo. Between 1:15 p.m. and 1:30 p.m. on Thursday, Steele and another male turned in the Monte Carlo at a Holiday Inn in Kingston, North Carolina.

Steele then attempted to get a chartered aircraft and hired a pilot for Rhodes Heating and Air Conditioning, Castle Hayne, North Carolina, to fly him to Hilton Head, South Carolina. About 5:00 p.m. on that same day, Steele rented a 1974 Plymouth with Georgia license plate number SA 705 from Avis Rent-A-Car at the Hilton Head Airport. Records showed that the car was to be returned at 5:15 p.m., Saturday, August 24, 1974.

At 7:34 p.m. on Thursday, August 22, Allen called his wife from a phone booth on Market Street in Savannah, Georgia, and asked her, "Are the men there?" She replied, "Yes." He asked, "What for?" She replied, "Abduction."

It was later confirmed that Allen drove by his house after he left the Hilton Head airport and saw the police cars and officers in his yard, so he did not stop.

August 27, 1974: Captain Gasque received a teletype from Corporal Sylvester of Daytona Beach, Florida Police Department stating that Steele had checked into the Diplomat Hotel in Daytona Beach on August 23, 1974. An agent with the FBI in the Daytona Beach area reported that a white male registered under the name of Jack Arthur and gave an address as 204, Fortieth, Savannah, Georgia. He was assigned room 208-A and paid for one night in cash. His departure date was indefinite. He listed his type of vehicle as a Plymouth, license number S or 5 (illegible)-8706. On August 27, 1974, the motel management notified the Daytona Beach Police Department that the occupant of Room 208-A had not been seen or heard from since the day he checked in, August 23. Officers came to the motel and searched Room 208-A. They located a South Carolina motor vehicle registration certificate dated August 17, 1974, in the name of Jack Steele for a 1974 Ford Bronco, South Carolina license LZN 122. The motel desk clerk was shown a photo of Jack Allen, and she identified him as the man whom she had registered as Jack Arthur at 7:55 a.m. on August 23, 1974. He had paid $24.96 cash for an oceanfront room. Records showed that he made a telephone call to Delta Airlines in Daytona Beach, Florida. Items found in his room were:

(1) Hertz Rental Agreement, dated August (date illegible), 1974, at Kingston, North Carolina for $26.09;
(2) Motel receipt in the name of Jack Steele, Holiday Inn, Memorial Drive, Greenville, North Carolina, dated August 22, 1974;
(3) Trailways bus ticket from Jacksonville, Florida, to Atlanta, Georgia, dated August 22, 1974;
(4) Plain suitcase containing clothes, ties, shaving gear, shells, a key chain with four keys and toilet articles.

In brief, the following were the approximate known movements of Allen from August 21, 1974, to August 23, 1974:

8/21/74—Wednesday

All morning	Drinking
1:00 p.m.	Leaves home
3:00 p.m.	Bought $250 diamond ring at St. George Jewelry Store
5:30 p.m.	Shooting at car on Interstate 26
6:00 p.m.	Abduction in St. Matthews
6:25 p.m.	Car seen on U.S. 176 and I-26, heading north

8/22/74—Thursday

12:00 a.m.	Victim (Mrs. Nancy Amaker) killed, according to autopsy
2:30–3:00 a.m.	Allen checks into Holiday Inn, Greenville, North Carolina, room 138; calls wife at home
9:30 a.m.	Deals at Hastings Ford Company, Greenville, North Carolina
11:00–11:30 a.m.	Vice-president of Hastings Motors calls Merritt Motors, Beaufort, South Carolina, to check legitimacy of Ford Bronco, then pays Allen $3,500
12:45 p.m.	Allen rents 1974 blue Monte Carlo at Holiday Inn, Greenville, North Carolina

1:15–1:30 p.m.	Allen turns in Monte Carlo at Kingston, North Carolina airport. Private plane flight from Kingston to Hilton Head, South Carolina
5:00 p.m.	Allen rents 1974 Plymouth Satellite, medium green with white vinyl top with Georgia license plate SA 705 (car to be returned at 5:00 p.m. on 8/24/74 at Hilton Head Airport)
5:50 p.m.	Body of Mrs. Amaker found 1.5 miles off I-95 Florence area
7:34 p.m.	Allen calls wife from a telephone booth on Market Street in Savannah, Georgia

8/23/74—Friday

| 12:01 a.m. | Allen at Trailways Terminal, Jacksonville, Florida |
| 7:55 a.m. | Allen checks into Diplomat Motel, Daytona Beach, as Jack Arthur, registers vehicle as Plymouth, license number GA 5 or S-8706 |

A search for the 1974 Plymouth Satellite failed to disclose the whereabouts of the vehicle. At this point, Law Enforcement lost track of Jack Allen.

Funeral services for Nancy Amaker were held on Sunday, August 25, at 1:00 p.m. in Columbia, South Carolina, with burial in the Hebrew Benevolent Society Cemetery in Columbia.

Kathy Riley Lowder remembers so fondly growing up in St. Matthews with her best friend, Nancy Read Linett:

We both had what we call "nurses" back then. "Nurses" would cook and help our parents with the kids. Nancy and Ricky's "nurse," Anna Mae, cooked the best fried chicken. Us kids just couldn't get enough of Anna Mae's fried chicken. Nancy and I went to Bible school together every summer. There was a Coke Bottling Plant in St. Matthews. We'd ride our bikes over to the plant and watch the workers bottle Coke. We got our driver's licenses when we were fourteen years old. We would sneak the car and ride for hours when our parents were at work, then put our change together to buy gas hoping they wouldn't find out, but the speedometer told on us. Nancy's dad ran the local "five and dime" store.

He let us work on the weekends for $5.00 a day. By the time Social Security was taken out, we took home about $3.75. Nancy introduced me to fried clams at Howard Johnson's Restaurant. I never eat fried clams without thinking of Nancy. She played the piano beautifully. Somehow she taught me how to play one of her recital pieces all the way through. She was a happy, loving person and a wonderful wife and mother.

Claire Dantzler Shuler, sister-in-law of author Shuler, shares some childhood memories of spending time with Nancy and her family:

In 1955 when I was ten years old, I lived in St. Matthews for a brief time. Nancy and I became friends and during the summer of that year we would go to the St. Matthews swimming pool where all the neighborhood kids would meet. Afterward we would go back to Nancy's parents, Mr. and Mrs. Linett's house, for refreshments and play. Her brother, Ricky, would play around sometimes just to aggravate us. We loved going down to her father's "five and dime" store to look around and to her uncle's department store, Savitz, and look at dresses. When school began that year we bought matching dresses from Savitz to wear to St. Matthews School's first football game. They were St. Matthews "yellow jackets" colors; yellow, black and white with a big yellow "sash tie." Nancy was a sweet, loving girl who loved life to the fullest.

The investigation continued with the assistance of the North Carolina State Bureau of Investigation (SBI). On August 26, 1974, FBI Special Agent Bill Danielson of Columbia, South Carolina, traveled to Raleigh, North Carolina, and met with SBI chemists and SBI special agents to examine and process the 1974 yellow Ford Bronco for any evidence that might connect the victim, Nancy Amaker, with it.

The Bronco was processed thoroughly inside and out and underneath. Indications were that the vehicle had been cleaned since the incident occurred on August 21. However, on the inside, numerous spots and smears of dark red material were noted on and below the right front seat, the right front floor mat, the right side of the dash, the right headliner, the right seat belt and holder, the right sun visor, the right door and the heater pipe under the right side of the dash. A red stain was also noted on the left door. Blood

spatter on the headliner and dash appeared to have originated from the area around the right front seat.

The vehicle was examined for fingerprints. No prints proved to be of any evidential value.

The rear floor mat and cushion were then removed and revealed a dark red liquid material near the center and rear center of the vehicle. The red stains and liquid were tested with Benzedrine (chemical used to test for blood), and all proved positive for blood.

SLED Lieutenant M.N. Cate and Agent Dan DeFreese delivered a blood sample from Nancy Amaker for comparison analysis with evidence collected from the Bronco.

Nancy Amaker's blood group was found to be O. Analysis of the bloodstains found on the seat belt holder and rear floor mat and red liquid from the rear center under the rear mat and cushion were group O. It was not possible to make confirmatory analysis on any of the other stains.

The investigation continued. Jack Allen remained at large.

Thirty-four harrowing days since Nancy's kidnapping, the nationwide search for Jack Leland Allen ended.

About 3:30 a.m. mountain time, Tuesday, September 24, 1974, a call came into SLED Headquarters from Phoenix, Arizona. Phoenix Police had arrested Jack Leland Allen.

Phoenix Detective Clark informed SLED Captain Gasque that Allen and a barmaid at the Sundancer Motel in East Phoenix were arrested about 1:00 a.m. during a gambling raid on the lounge at the motel. Allen and others were playing what was called the "high pill" game. (Balls with numbers on them are placed in a bottle. Shake the bottle and turn the balls out. The high number wins.)

Detective Clark said that Allen put up a little bit of a struggle, tried to run from them and even tried to bite one of the officers, but he later settled down. He kept telling Clark that his name was Dennis Ricky Douglas. Items were found on his person with the name "Jack Steele," but he finally admitted that he was Jack Leland Allen. After running a check on Allen, Clark found that he was wanted by South Carolina authorities and the FBI.

Although Allen was wanted in Michigan on numerous charges, South Carolina charges of kidnapping and murder had first priority.

Allen did not fight extradition back to South Carolina. Sheriff Rucker and agents with SLED flew to Phoenix on a state-owned airplane on

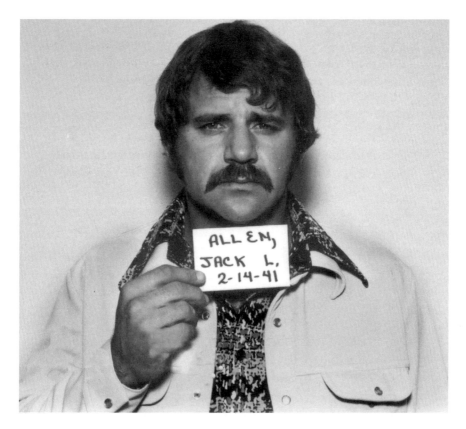

Jack Leland Allen's arrest photo. *Courtesy of SLED.*

Wednesday, September 25, to pick up Allen. He was clad in belly chains and handcuffs the entire trip. They arrived back in Columbia late Wednesday night. Allen was incarcerated and allowed to rest until the next morning.

Allen was transported to SLED headquarters Thursday morning, photographed and interviewed by Captain Gasque for about four hours. After lengthy questioning, Jack Allen gave a four-page written statement:

State of South Carolina
County of Richland

Personally appeared before me, Jack Leland Allen, white, male, who after being duly sworn deposes and says:

My name is Jack Leland Allen. My address is Hardeeville, South Carolina. I am thirty-three years old. I completed the twelfth grade in school, and I can read and write. I completed two years of college.

I have been advised that I have the right to remain silent and that anything I say can and will be used against me in a Court of Law. I have been advised that I have the right to talk to a lawyer and have him present when I am being questioned. I have been advised that if I cannot afford a lawyer, that the State will appoint one to represent me without cost. I have been advised that at any time during the questioning, if there is any particular question that I do not want to answer, that I do not have to do so. I have been advised that I can terminate the questioning at any time by saying that I do not wish to answer any more questions. I understand these rights, and I waive these rights, and I make the following statement:

My name is Jack Leland Allen, and I have been known as Jack Steele while residing in South Carolina for approximately fourteen to eighteen months. I have been residing at Hardeeville, South Carolina, with my wife and two children. On August 21, 1974, I left my trailer near Hardeeville with the purpose of going to Atlanta, Georgia to seek employment. I do not recall leaving my home on that day, but I later discovered I was driving my 1974 Ford Bronco which is yellow with a white top. I am not aware of when I left home, nor at the time I left home do I remember for what reason. I do recall now that the day before I left, I had advised my wife that I was going to Atlanta, Georgia to seek employment, and that I would return home in a couple days. I had been drinking from about daylight that morning until the time that I left home. When I left, I was under the influence of alcohol. I now recall having in my vehicle my clothing, a .38 caliber Charter Arms revolver, a Beretta over-under twelve gauge shotgun, and a Browning automatic twelve gauge three inch magnum shotgun and some ammunition. My first recollection of having left home on August 21, 1974 was when I stopped at a liquor store in Ridgeland, South Carolina. I bought a bunch of booze. I don't recall how much. I recall that I later stopped at a jewelry store in St. George, South Carolina for the purpose of buying my wife a diamond ring because it was her birthday. I gave the jewelry store a check but don't recall the amount. I later recall waking up at a rest area on an Interstate. I do not recall what time I woke up at the

rest stop, but it was still daytime and on August 21, I was still boozed up, and I decided to pull an armed robbery. I do not recall how I was dressed on August 21, 1974, but I do wear a Saint Christopher metal around my neck.

I went into a small town looking for a place to rob. I don't recall the name of the town. I went into a clothing store, and a girl saw me as I was about to pull my gun. I thought she saw the gun, and when she turned to leave the store, I turned and followed her out on the sidewalk. I remember pulling my gun on her, and I planned to carry her back in the store while I robbed it, but when I pulled my gun on this girl, a woman and some other people saw me and the gun, and I decided to carry this woman away with me. I forced her into my yellow Bronco. I recall leaving town with the girl, and I had my gun on her all the time. She told me her name was Nancy Amaker. She was approximately thirty years old, was approximately five feet four or five feet five inches tall, had sandy brown hair and she wore glasses. She had a short dress to the best of my memory. I don't recall the color. I do recall that she had some dresses in her arms. I do not remember anything about the town except it was a small town and the store was on or near a corner. While we were driving away I kept my .38 on her. She kept saying, 'You're not going to kill me?' and I told her I was not...that I wanted to get her to Columbia, and that I would free her. She directed me as to how to get to Columbia. When we got to Columbia, I became frightened and afraid to release her because of the largeness of Columbia and its heavy population. I knew that I could not free her in Columbia and still get away, so I asked her to direct me to a small town and that I would free her. She gave me directions. I do not recall where we went, but I do recall it was east from Columbia. I had started drinking again at this time. I do recall her asking me if I was going to rape her. I told her I was not. I don't recall how long we drove or where we stopped. I do recall it was several hours later. I also recalled that we stopped for gasoline, but neither of us got out of the automobile. I do not know when we stopped for gasoline or where. I do know that when we got gasoline, it was after we passed through Columbia. When we stopped again, I told her to get out of the automobile, and I got out the automobile. I told her to take her clothes off and lay them on the seat of the car. I recall that we were back of a field just off a dirt road when I had her undress. She asked me if I was going to rape her and told me that she was menstruating. I told

her that I was not going to rape her. After she had taken her clothes off and laid them on the front seat, I saw a light come on at a house nearby and ordered her back into the automobile. The reason I had her take her clothes off was because I felt she would be hesitant to go out on to the highway if she was nude, and this would give me more time to get away. After I saw the lights go on, I ordered her back into the vehicle and drove away from the field back on to a dirt road. Shortly after I got on to the dirt road, she became hysterical. I pointed the gun at her and told her to calm down. She did not and I shot. I do not know whether I shot her accidentally or intentionally. She slumped over in the car, and shortly after that I turned on to a paved road. Shortly after that, I stopped the car, got out and went around to her side. I lifted her out of the car and laid her along the side of the road in the edge of the bushes just off the highway. I then got back into the automobile and headed north. I stopped at the first town and went to one of those quarter self-service auto washing places and cleaned the vehicle up. I put all of her clothes in a plastic bag and headed north again. I got back on the interstate and somewhere between that point and my reaching Greenville, North Carolina, I threw the plastic bag with her belongings out of my car. I was drinking again, and I do not really know what I did with her belongings. I want to state to the law enforcement officers that I did not rape Nancy Amaker. I did not have sex relations with her orally nor anally. She did not have oral sex on me nor did I force her to have oral sex on me. I did nothing sexually to Nancy Amaker. I did not bite or scratch her on the back or anywhere else on her body. I continued on to Greenville, North Carolina, and when I reached there, I checked into a Holiday Inn. The next day I sold the automobile after removing the license tags. I rented an automobile and drove to Kingston, North Carolina where I chartered a private aircraft to carry me to Hilton Head, South Carolina. I rented an automobile at Hilton Head and drove to Bluffton where I attempted to call my wife, but the operator advised me that there was trouble on the lines. I drove by my trailer and continued on to Savannah, Georgia where I placed another call and talked to my wife briefly. I then continued on to Daytona Beach, Florida. Shortly after getting into the state of Florida and before I reached Daytona Beach, I threw the .38 revolver that I had shot Nancy Amaker with into a river. I do not recall where nor the name of the river. I got to Daytona Beach and checked into a motel, but didn't like the looks of

it and went up the beach and checked into another motel. I stopped at a clothing store and bought some more clothes and drove to the airport in Orlando, Florida where I caught a flight to New York. I left the rental car that I had got in Hilton Head, South Carolina in the parking lot at Orlando, Florida. In the back seat on the floor of that vehicle, I left the two shotguns that I have described to the law enforcement officers, both in cases, and the license plates that I had removed from the Ford Bronco and other personal belongings. Since leaving Orlando, Florida, I have moved around constantly across the continental United States until I was arrested in Phoenix, Arizona on Thursday, September 24, 1974.

I make this statement of my own free will and accord, without reward or hope of reward. I have not been mistreated or threatened in any way. All of the above is the truth, the whole truth, and nothing but the truth, so help me God.

(Signed) Jack Leland Allen

SWORN to and subscribed to before me this 26ᵗʰ day of September, 1974.

(Signed) Captain Leon Gasque
Notary Public for South Carolina

WITNESSES:
(Signed) Elliot Rucker
(Signed) Joseph D. Stack
(Signed) L.C. Kemmerlin
(Signed) Vic S. Deer
(Signed) Dan F. Beckman

THIS IS TO CERTIFY THAT I HAVE READ THE ABOVE STATEMENT CONSISTING OF FOUR PAGES AND HAVE BEEN GIVEN A COPY OF SAME AS OF THE 26ᵀᴴ DAY OF SEPTEMBER, 1974.

(Signed) Jack Leland Allen

After Allen signed his original statement, Gasque and Allen discussed the location of Mrs. Amaker's body and where the shooting of Mrs. Amaker had occurred, with respect to where the body was found. Allen said that the body was found in a different location from where the shooting had occurred. He attempted to describe where the shooting had occurred and where he hid the body. He said, "I probably would have hidden the body a little better, but I heard a vehicle coming up the road, so I got back into my car, drove down the road to the next area, then turned around and proceeded back to the interstate."

Captain Gasque made a determination to carry Allen to Florence to let him point out the exact area of the shooting. Gasque called Allen's attorney, Luke Brown, and asked if he had any concerns about him carrying Allen to the Florence area for the specific purpose of confirming the county where Mrs. Amaker was shot. Mr. Brown said he did not have any concerns and would allow it. Conferring back with Allen, Allen told Captain Gasque, "I won't go down there with you and point anything out to you."

As a result of Allen's refusal to go to Florence, Gasque asked him to draw a sketch of the area and if he would talk to the sheriffs of Florence and Darlington Counties. He had no problem with that—he drew a workable sketch and consented that he would talk to the sheriffs.

Gasque contacted Florence County Sheriff Billy Barnes and Darlington County Sheriff Jack O'Toole. Sheriff Barnes and O'Toole and Sheriff O'Toole's chief investigator, Gene Elliott, traveled to Columbia the following morning, September 27, and interviewed Allen. Along with the sketch, Allen went into great detail telling them about his travels after he got off Interstate 95 in the rural area where he shot Mrs. Amaker and where he put her body.

That afternoon Sheriffs Barnes and O'Toole and Investigator Elliott went to the area off Interstate 95 that Allen described to them, and they found everything as he described it. The wooded road where Allen stated to them that the gun went off was in Florence County. The location where he put Mrs. Amaker's body was about forty feet from the edge of the bridge in Darlington County. Sheriffs Barnes and O'Toole and Investigator Elliott concluded that Allen's description of where the shooting occurred placed the murder of Mrs. Amaker in Florence County.

Gasque questioned Allen about the car that he had rented from Avis Rent-A-Car at Hilton Head. Allen said it was a 1974 Plymouth Satellite, medium

green with a white vinyl top, and on Friday, August 23, 1974, he abandoned the car at the Municipal Airport in Daytona Beach.

Gasque contacted Captain F.W. Perrin with the Daytona Beach Police Department for assistance in possibly locating the rental car at the airport. He informed Captain Perrin that at the time of abandoning the car, it possibly contained two shotguns in cases and 1974 South Carolina license plates, number LZN 122.

Captain Perrin located the Satellite parked in the Avis rental area at the airport and reported that it appeared to have been opened and then re-locked, as there was chipped paint and markings along the molding of the left driver's window. Perrin then proceeded to open the vehicle with a coat hanger. The following items were found in the vehicle: a pair of 1974 South Carolina license tags, LZN-122; two 8-track tapes (*John Denver's Greatest Hits* and a Falcon cleaning head); a key to Watson's Beach Hotel, Daytona Beach, Florida; an Avis rental car contract for the 1974 Satellite; two gun cases; one Beretta BL3 trap, 12-gauge shotgun; one partial box of #4, 12-gauge shotgun shells; and one green-covered notebook with several entries. One entry read, "Get gun at Crannans," and another read, "Get Beretta from Jeff."

Jack Leland Allen was a self-described "habitual criminal" who had spent only about three years of his life outside prison since he was sixteen. He was born in Grand Rapids, Michigan, in 1941, one of eight children. Four of his siblings were stillborn, and his brother, who was a year older than Allen, died when he was one year old. He had one living older brother and one living older sister. In his early childhood, his mother worked in a bakery and did ironing at home for extra money. His father picked up scrap metal from dumps with his pickup truck to sell. As early as nine years old, Allen got into trouble for running away from home and truancy. When he was twelve years old, he and two other boys stole a car from a lounge and drove it until it ran out of gas. He was arrested and placed on an undetermined period of probation by the Probate Court and placed in the custody of his maternal grandmother. He lived with his grandparents for two years and was a straight A student. He was doing well at home and school.

After two years, he was sent back to live with his parents but did not readjust. During this time, he was pretty much left to his own devices. Within thirty days, he was again in trouble with school authorities for truancy. He went from one school to another in Grand Rapids. When he was thrown out of one school he just went and enrolled in another. In 1957, at the age

of seventeen, he stole a car and again was placed on probation. Thirty days later he broke probation when he went into a home and stole silver dollars. He was sentenced to one to five years in the state reformatory. His following years were mostly spent in and out of prison on one after another burglary counts. He was infamous for escaping and committing yet more burglaries, which landed him back in prison again and again.

In Detroit, Michigan, in 1966, he escaped from prison and committed numerous armed robberies. On two occasions, he took a male hostage sixty to seventy miles from the scene to an isolated area and released him. In time he was apprehended and sentenced to twenty years. Again his escape tactics began, and he was transferred from one prison to another, including Leavenworth, Kansas; Marion, Illinois; Milan, Michigan; Terre Haute, Indiana; and Jackson, Michigan.

In December 1966, Allen met his wife, Joy, when he was being held in Cole County Jail, Jefferson City, Missouri, on a federal charge of attempted escape and kidnapping. Joy's car had been stolen from a downtown area while she was at work. She went to the jail to see an investigator regarding the charge against the two persons who had stolen her car. Allen was in the same office dressed in civilian clothes and spoke to her. She did not know that he was an inmate, and they talked for a few minutes. Allen told her that he was a prisoner and he had no family or friends and would like very much to talk with her again. They started to correspond, she was permitted to visit him in jail and a relationship developed. Allen was later transferred back to prison in Grand Rapids, Michigan. Joy followed him there. The relationship continued, and they were married in prison in July 1970. Allen obtained two years of college credits while he was in prison and earned a bachelor of arts degree in history.

In September 1971, he was released on parole in Grand Rapids, Michigan, and went home to his wife. He got a job as a pattern maker for a furniture company. His wife was a stenographer for an insurance company in Grand Rapids. Their daughter, Amy, was born.

Allen's mother died in March 1972. Allen assaulted his mother's doctor because he felt that she died because of the doctor's medical error and neglect. The state parole officer told him that if he was charged for the assault, he would be sent back to prison. He and his wife made the decision to take all of their household belongings, dispose of them and go to some other place and reestablish themselves under an assumed name so that they

could be together. Jack Allen took the name of Jack Steele. He got the name of "Steele" from a former cellmate in prison. In April 1972, he, his wife and daughter left the state of Michigan and traveled back and forth across the continental United States. If they ran out of money, "Steele" would just go out and pull off a robbery.

In November 1972, they settled in Hardeeville, South Carolina. Allen applied for a Social Security number under the name of Jack Steele and got a job with the Hilton Head Company.

Allen had at least three outstanding warrants in Michigan for fraud, robbery and parole violations and one for the assault of his mother's doctor.

During an interview with Allen's wife, she told investigators that the reason they came south and settled in Hardeeville, South Carolina, after wandering around for almost seven months in the West was because they wanted Lowcountry warmer weather and less expensive conditions. "We wanted a slow country kind of atmosphere completely different from Los Angeles and Detroit that Jack and I knew. We wanted horses in our back yard, not ghettos. We wanted schools with interested teachers, not fifteen hundred to three thousand students in one building, so we came south for the type of life we could live here."

On October 15, 1974, the Florence County grand jury met and returned an indictment charging John Leland Allen with willful, deliberate and premeditated murder while committing the crime of kidnapping with the use of a deadly weapon. He was arraigned later that same day.

In Florence, South Carolina, on Wednesday, March 5, 1975, Jack Leland Allen went on trial for his life for the murder of Nancy Linett Amaker. This would be the second case to be tried under South Carolina's new death penalty statute that was passed by the South Carolina General Assembly in July 1974 (Acts and Joint Resolutions of the General Assembly of the State of South, Section 1-16-52). It includes:

> *Whoever is guilty of murder under the following circumstances shall suffer the penalty of death.*
>
> *Murder committed while in the commission of the following crimes or acts: (a) rape; (b) assault with intent to ravish; (c) kidnapping; (d) burglary; (e) robbery while armed with a deadly weapon; (f) larceny with the use of a deadly weapon; (g) house-breaking (h) killing by poison; (i) lying in wait.*

Murder that is willful, deliberate and premeditated.
Whoever is guilty of murder under any circumstances not listed shall
suffer the penalty of life imprisonment.

The Honorable George T. Gregory Jr. was the presiding judge. T. Kenneth Summerford, solicitor for the Twelfth Judicial Circuit, was representing the State of South Carolina.

Jack Allen was represented by Ernest Hinnant, public defendant of Florence County; Mr. Luke Brown Jr., attorney at law from Ridgeland, South Carolina; and Mr. Harry Bozard, Orangeburg County's public defender. Because this incident occurred in Calhoun County, which is the adjacent county to Orangeburg, by order of the resident judge of Florence County, Bozard was appointed to represent the defendant.

During a pretrial hearing on Tuesday, Mr. Hinnant asked for a change of venue because Mrs. Amaker's body was found in Darlington County. Judge Gregory denied the request, stating that investigation concluded that Mrs. Amaker died in Florence County, and under South Carolina law, the trial is held in the county where the murder occurred.

Also during the pretrial hearing Tuesday, Allen rose and admitted to the court openly, "I don't want to subject anyone to any more emotional stress, and I don't want to avoid punishment for what I have done. I would like to dispose of it with a plea. I want to say that I did not premeditatedly shoot the woman." Because Allen said in his signed statement that he did not know whether he shot Mrs. Amaker accidentally or intentionally, his attorneys wanted to have that part of his statement thrown out of court. Judge Gregory said that he would rule on the validity of the admission of the statement if and when it came up.

Discussions among Allen, his attorneys and the prosecution went well into the late hours Tuesday night.

On Wednesday morning, Allen, dressed in a white, western-style suit opened at the collar, sat with his lawyers at the defense table. His wife, Joy, sat behind him. At times she had their two children in the courtroom with her.

Judge Gregory announced that the prosecution refused Jack Allen's guilty plea to non-premeditated murder and the trial would proceed under the charge of murder contained in the indictment.

A jury of nine women and three men was seated Wednesday afternoon.

Forensic Pathologist Dr. Sandra Conradi was the state's first witness. She explained that the fatal injury that caused Mrs. Amaker's death was a gunshot to the back of her head. The wound indicated that the gun was held tightly against her head when it was fired. There was no evidence presented as to whether Mrs. Amaker was sexually assaulted.

Employees of Savitz Department Store, Margaret Clement and her daughter, Becky, testified to what they witnessed the afternoon Mrs. Amaker was kidnapped. They all held strongly to the statements they had given officers the day of the kidnapping. They were all asked if they saw in the courtroom the man whom they had seen with Mrs. Amaker on Wednesday, August 21, 1974. They all identified the defendant, Jack Allen.

Pharmacist Carol Horton testified to what he had told investigators of his observation on the Wednesday evening of the kidnapping. A yellow Ford Bronco pulled up behind him at a stop sign at the intersection of Highway 176 and Doodle Hill Road outside of St. Matthews. When the Bronco passed him, he observed the head of another person rising up from the seat next to the driver. He remembered the letters M-E-R and possibly a T on the plate around the license.

Mr. Dargan Isgett, next to take the stand, gave details of finding the body of a white female on Thursday, August 22, in the edge of the bushes near the Back Swamp Bridge on Highway 327 right next to the Darlington County sign and informing Deputy Sheriff Coker O'Neal with the Darlington County Sheriff's Office.

Captain Leon Gasque testified to interviewing Allen after his arrest and obtaining his written statement. Solicitor Summerford asked Captain Gasque about the condition of the defendant at the time of the interview.

"He appeared to be alert, awake and in possession of his faculties as I recognize them as a layman. He was coherent and appeared to understand all my questions and answered them intelligently. I asked him several times how he felt. We gave him water and food, allowed him to smoke and use the restroom whenever he needed to."

"Did he make an oral statement to you?"

"We discussed the events surrounding what had happened to Mrs. Amaker. Then I asked if he would give me a written statement. I explained to him that we would bring in a recording secretary and have him give a statement. She would then read her shorthand to him, requesting that he make any corrections at that time, and then she would transcribe her shorthand notes

into the English language. He would read the transcript of his statement and sign it when he was totally satisfied that they were his exact words."

"Did he read it and sign it in your presence?"

"Yes, myself, Sheriff Rucker and four SLED agents witnessed him read and sign the statement. I am a notary public, and I also notarized it. Mr. Allen was then given a copy."

At this time the jury was removed from the courtroom. Out of the presence of the jury, the court took up the matter of the admissibility of Allen's statement.

Allen was called to the stand, sworn in and handed a copy of his signed statement. He was asked to read some of his words that had been underlined and to tell whether those words were as he gave them to the officers: "I drove away, and as I was driving away she became totally hysterical. I attempted to calm her down and settle her down in the seat, and had the gun in my hand and the gun discharged."

He looked up from the statement and commented,

The gun was in my hand…the gun did go off…the woman was shot and she did die, but at the time that happened, I did not know how it happened, and I indicated to Captain Gasque very honestly that I did not know how that happened. And in saying accidentally, or intentionally, at the time I was afraid that I may have lost my mind. I stated it to several SLED agents at the time that I just didn't know how the gun discharged, but this is not verbatim how it's written in the statement here. Being in the emotional state that I was in at the time that this statement was made, I did not read this statement carefully or closely. I signed it. Essentially it is true. I don't deny the fact that the gun was fired.

"Jack, did you read this statement at the time you signed it?"

"No, not word for word. I said that I did…I glanced at it…said I did. I was in a situation where I wanted to have it done with. I wanted to have it finished."

"Why were you in an emotional state?"

Remorse, regret for what had taken place, concern for my family, concern for the family of the woman, concern for everybody involved. I wanted it done with. As a matter of fact, the SLED agents can tell you that at the

time I was ready to volunteer for the electric chair, because I didn't know what had been done. I wasn't sure, but I'm clear in my mind now. I know that I did not intentionally shoot that woman. I have never changed what I said. What I'm saying now is that what I said was reduced to writing in words that I did not use. It shows a different idea than the one that I was intending to express. I was very clear in expressing this when I gave this statement. It just wasn't reduced to writing in the same way.

After almost three hours of questioning, Allen's attorney asked that Allen's signed confession not be allowed to be introduced into evidence on the grounds that portions were not accurate. Judge Gregory announced that because of the lateness of the evening, he would rule on the admissibility of Allen's statement the next morning.

On Thursday morning, Judge Gregory ruled that the confession signed by Jack Allen after his arrest on September 26, 1974, would be admitted as evidence.

After the jury was brought in, Captain Leon Gasque was called back to the stand. He gave in-depth details from the time he entered the investigation of Mrs. Amaker's kidnapping, her murder, tracking Allen's movements, interviewing Allen after his arrest and obtaining his written statement.

Solicitor Summerford offered Allen's four-page statement into evidence. Judge Gregory admitted the statement into evidence and allowed Solicitor Summerford to publish it verbatim to the court. While the statement was being read, Allen leaned forward and bowed his head.

After the reading of the statement, the solicitor asked Gasque what, if anything, was discussed with Allen after his written statement. He offered the details of his discussion with Allen about going to Florence and showing him exactly where the shooting took place, and as a result of Allen's refusal to go, Florence County Sheriff Billy Barnes and Darlington County Sheriff Jack O'Toole came to SLED Headquarters and talked to Allen.

Sheriff Billy Barnes followed with testimony of his conversation with Allen, which resulted in him, Sheriff O'Toole from Darlington County and his chief investigator, Gene Elliott, going to the area where Allen said the shooting took place. He went into Allen's precise details of his directions:

He turned off I-95, onto Exit 327 and crossed back over the interstate and passed a paved road to the left. He did not turn down the paved road.

He continued on down Highway 327. He passed a dirt driveway going up to a house on the right. He went on down just a few more yards, turned left down a dirt road that went through a patch of woods over a hundred yards long and came out to a bean field on the left. Where the bean field and the road came together formed sort of a point. He turned back around and drove between the woods and the field about fifty feet. That's where he got the victim out of the car and told her to take her clothes off. Then he saw a light behind him and it scared him, so he put her back in the car, backed out and drove back to where he came in. He had the gun to her head as he was going back through the woods and she became hysterical and the gun went off. He drove back out to the paved road, turned left, went down a few yards and crossed a bridge. He pulled off to the right side of the road at the bridge and put the body out. Everything he described, we found.

Solicitor Summerford asked Sheriff Barnes if this was in Florence County or Darlington County. Sheriff Barnes replied, "The woods road where he stated that the gun went off was in Florence County, and where he placed the body was in Darlington County. The distance between where he said the gun went off and where the body was found was about two hundred yards."

Robert Floyd, tax assessor of Florence County, testified that his records indicated that the Florence/Darlington County line would be approximately the middle of the Back Swamp Bridge or down the run of the stream, and the tract of land in question where the shooting took place was in Florence County.

Photos of the scene that were taken after the body was removed were entered into evidence. SLED Agent Jim Springs testified that he went to the scene, photographed the area and made measurements from the bridge to the exact spot where the body was discovered. Pointing to the photos, he explained, "There is a tape measure shown in the photo and upon measurement it was found that the body was discovered approximately forty feet from the edge of this bridge depicted in the photo."

William McClume, vice-president of Hastings Ford in Greenville, North Carolina, took the stand and gave the details of purchasing a 1974 yellow-and-white Ford Bronco registered to Jack Steele on August 22, 1974, for $3,500. He was questioned by Solicitor Summerford as to whether he saw

The body was discovered in Darlington County approximately forty feet from the edge of the bridge. *Courtesy of SLED.*

stains or anything of that nature when he inspected the Bronco, to which he replied, "Mr. Steele pointed to bloodstains above the right sun visor and said they were deer bloodstains. There was a mat covering the back floor, and when the FBI tore the truck down for investigation, under that mat there were some bloodstains."

With this witness, the state rested.

Defense testimony began late Thursday afternoon. Allen's wife, Joy, took the stand. Mr. Brown asked how old she was and how many children she and Jack had.

"I'm twenty-eight. We have two children. Amy is five years old. John is eight months."

He then asked how she came to know the man she knew as Jack Steele.

She explained how she met Jack in prison in 1966 and married him in prison in 1970. "He got out of prison in Grand Rapids, Michigan, on parole in September 1971, so except for those three years between September 1971 and August 1974 he was always in prison."

She said the reason they left Michigan and traveled around before they settled in Hardeeville was that Jack had broken his parole because of the altercation with his mother's doctor.

When asked if she knew that Jack committed armed robberies during that time, she replied, "No, he never involved me or told me what he did when he left me."

Mr. Brown asked Mrs. Allen how Jack happened to leave home on August 21, 1974, and in what condition he was when he left.

Jack had been depressed and completely unresponsive for a period of a week or more mostly because of the way we were living. We couldn't establish a background and that made seeking employment almost impossible. We couldn't enroll our daughter in school because we were living under an assumed name. We had no way of correcting the birth record without exposing ourselves. We couldn't make contact with anyone who could help us through a financial crisis, because we would have had to expose the area where we were living. It just kept getting worse and worse, and it was tearing Jack up. We even talked about turning himself in, doing the fifteen years and starting over. I begged him not to.

"Tell us what occurred on the morning of August 21, 1974."

"Jack had been drinking since dawn. Amy got up and dressed and went out to play. I joked with Jack, but I was worried about his drinking. He asked me if I trusted him, and I said yes. He said he would quit drinking for the day. I fixed him some coffee. He took a shower. When he came out the shower, he told me he was going to Atlanta to look for work."

"He was driving his yellow Bronco?"

"Yes."

"When was the next time you heard from Jack?"

"Around ten o'clock that night on August the twenty-first."

"What did Jack tell you at that time?"

"He sounded extremely upset. I asked him if anything was wrong and he said yes, and he would talk to me about it when he got home. He asked if everything was all right at the house and how Amy and John were, and said that he would be home quickly."

"When was the next time you heard from him?"

"Thursday morning, and he told me he was on the way home. Again I asked him if anything was wrong, and he said it was a mistake leaving the house and we would discuss it when he got home. That was the end of the conversation. I could sense it in his voice that something was wrong."

"When was the next time you heard from him?"

"Around seven o'clock Thursday night when the officers from SLED and the FBI were at my house."

"What did he say?"

"He asked me, 'Are the men there?' I said, 'Yes.' He said, 'What for?' and I said, 'Abduction.' He said, 'Goodbye,' and hung up."

"When was the next time you heard from him?"

"I don't recall the day. It was after he had been apprehended in Phoenix, Arizona. He called collect and used his legal name, Jack Leland Allen. Of course by then I knew most of the investigation as it progressed. I knew then that because he used his legal name, he had been apprehended."

"Have you visited your husband in prison since he came back?"

"Yes, I have visited. I even moved to Columbia so I could be as close to my husband as I can and take the children to see him as often as I can. My daughter had a very difficult time after her father left. It wasn't until the first visit with Jack did she really believe that he hadn't left us willfully and that her daddy really loved her."

"Is living in cities with prisons been the pattern of your life since you married him?"

"Yes, sir."

"If from this case he receives a prison sentence, do you intend to still follow?"

"Yes, sir."

"What type of person is Jack, Mrs. Allen?"

"Jack is a very concerned individual. With me he has always been loving and giving…more concerned about my needs and wants and comforts than his own. He is the kind of man that would go without all of his own comforts to see that we had what we needed."

"How about as far as violence is concerned?"

"I've seen Jack violent only on one occasion, and that was the time when the doctor termed his mother's death, not as negligence, but as a medical error. He has never struck me or our children in anger."

"Is there anything else you would like to say?"

"Yes. I've seen what this has done to my husband. I've seen his almost lack of will to live from the burden of it. I've seen what it has done to him emotionally, physically, mentally from the grief he carries and remorse…and I carry it, too."

"Nothing further."

On cross-examination, Solicitor Summerford questioned Mrs. Allen in great length about Jack's criminal records of burglaries, armed robberies, kidnappings, prison incarcerations and attempted and successful escapes for as long as she had known him. He asked her about when he was paroled in 1971 and they traveled all over the continental United States living under an assumed name and then settled in Hardeeville, South Carolina, in 1972.

She told again how Jack was drinking the morning of August 21, 1974, and when he left home he was extremely intoxicated.

The solicitor asked, "Well, you couldn't keep him home?"

"No, sir."

"So that same loving husband that you described to this court and jury that is so attentive and such a great father and husband, and only one time has he ever lost his temper, according to your testimony?"

"That's right."

"The truth of the matter is you love your husband and you want to help him, and you will do anything to help him, won't you, Mrs. Allen? That is your real name, isn't it?"

"Yes, that is my name, and yes I wanted to help him bad enough, sir, to offer to turn myself in as bait to bring him back in alive. I was willing to risk my marriage, which is everything to me, to get my husband to surrender."

"I have no further questions."

On redirect, Mr. Brown asked Mrs. Allen, "As a matter of fact, at the request of Captain Gasque to attempt to locate your husband, didn't you make innumerable telephone calls?"

"I called everybody that I could remember that Jack and I had met prior to the time that we came to South Carolina and during the time that we were running. I thought that he might attempt to reach someone we knew. My phone bill was about $500."

"So he would be brought back alive?"

"Yes, sir."

"No further questions."

Neighbors of Jack and Joy Allen were called as character witnesses for Allen. They both said that Allen was very loyal to his wife and family—the perfect family man. He was a deeply compassionate and very intelligent man. One of the neighbors worked with Allen and said that he was hardworking, conscientious and followed his tasks to completion.

Jacqueline Summerall, a friend of the Allens who had known them since February 1974, said that Jack Allen was an honest and devoted family man.

Mr. Brown said to the witness, "You say that Jack Allen was an honest man. That is, honest except for the fact that he did not tell you his real name and his background. Would that have made any difference?"

She answered, "No."

Solicitor Summerford cross-examined Mrs. Summerall. "You've known a person for six months and you find out he was living under an alias name, and it hasn't changed your opinion at all?"

"No."

"How about the armed robbery, burglaries, larcenies and the kidnapping, that hasn't changed your opinion either, has it?"

"No."

"You still think he is a wonderful guy, isn't he?"

"I think so."

"There is absolutely nothing that would change your opinion about that man, even killing a woman, is there?"

"No, I don't think so."

The solicitor had nothing further for the witness.

At this point, Mr. Brown informed the court that the next witness would be Jack Allen himself. The defense believed that it would be a lengthy testimony both for the defense and the state, and because of the late hour, he asked Judge Gregory to consider that court be adjourned for the night. Judge Gregory agreed and adjourned court.

On Friday morning, March 7, Jack Leland Allen took the stand. Out of the presence of the jury, Judge Gregory addressed Allen and informed him that his attorneys purposed to call him as a witness on his own behalf. "You have the right, and it is your decision to testify or not to testify. It is not counsel's decision. Of course, the state could not ask you to take the witness stand, but upon you being sworn, you will be examined by the state as well as by your own counsel. The decision is your decision."

Allen replied, "I am totally willing to testify, your Honor."

The jury was brought in.

Mr. Brown asked Allen to state where he was born, his birth name and age.

"I was born in Grand Rapids, Michigan. My birth name is Jack Leland Allen. I was born in 1941, and I am thirty-four years old."

After brief questioning about his parents, siblings and early childhood, Mr. Brown asked when Allen first had trouble with the law.

"I was nine years old, and it was for truancy."

Mr. Brown led Allen through the years of criminal acts that landed him behind bars since he was sixteen years old. Brown questioned him in great detail. Allen answered in great detail. At one point Brown asked him about taking his first hostage.

Allen explained,

> *In 1966, I was placed in an "honor farm"* [low-security prison located outside state penitentiary walls for inmates who had demonstrated good behavior]. *I walked away from the farm, stole a car and went to my hometown. I found no one there that would help me, and I went to the city of Detroit. I robbed a bar and made the man in the bar go to his car and drive me to Toledo, Ohio. I left him in an isolated area and drove back into Toledo. I left the car behind*

a bar, called the police and told them where the car was, so he got his car back.

Mr. Brown continued with Allen's history of crime. Allen continued with his lengthy details of each incident. While giving details of being on parole in 1972, Allen said that he wanted to make something very clear. "While we, my wife and daughter, were traveling around from one part of the country to another, and I felt that I had to steal money to support them, at no time was my wife or child permitted to know about anything I did. I would go to a motel, check in, leave, steal money, come back and then take my family on with me."

Brown asked Allen, "Prior to the shooting of Mrs. Nancy Amaker, did you ever shoot a person or attempt to shoot a person in any other robberies?"

Allen answered, "No."

Allen was then questioned about his written statement that he gave at SLED Headquarters on September 26, 1974. In a monotone voice, he continued with his answers in great detail. He did not stray from his written statement as to what happened on August 21, 1974, when he left Hardeeville, ended up in St. Matthews, abducted Nancy Amaker, headed toward Columbia and then left the highly populated city because there was no isolated place to let her go without her being able to get to a telephone within seconds of being released. "She told me the direction to go. We passed through many small towns, one after another. I just wanted to find an area where I could let her go in the country. That's when we ended up off I-95 in the country."

He continued with his detailed account, as written in his statement, of his movements and then shooting Mrs. Amaker. But this time his story changed slightly:

> *When she became hysterical, she attempted to go out of the window or the door. She was moving to the side, and I reached out to her and having the gun in my hand, tried to push down on her shoulder, and the gun went off. I did not shoot her intentionally. It was an accident. I don't recall the car even stopping at all during this part of what happened. I immediately stopped the car and listened...It was silent, her hand was laying on the seat in the passenger's side, and I felt her wrist. She was dead. I lifted her body out near a bridge and laid it next to the car.*

Mr. Brown asked, "Did you intend to kill Mrs. Amaker?"

"No, I did not."

He completed the rest of his story about being apprehended in Phoenix, Arizona, on September 24, 1974. "The detectives came in the bar, and we talked to them. I bought them a drink, and they bought me a drink. We talked and the lady bartender had a little milk bottle that had numbered balls in it, and we gambled for drinks. We ended up getting arrested."

Mr. Brown asked Allen how he felt about his life of crime.

> *I think it has been a terrible waste. I think I've betrayed people who gave me total devotion, and I'm sorry, and I have absolute and total remorse and regret for the death of Mrs. Amaker. I did not intend that, and I don't want to escape punishment for that crime. The only thing that I cared about was that I wanted everyone involved to know the true facts. I wanted her family to be relieved of as much grief as possible. I do not want her husband to bear the additional burden of thinking that she had been abused in any way prior to her death. I don't feel that I should be freed or exonerated of the responsibility for her death. I accept that responsibility. I accept the responsibility for grief that has come to her family, and what I have done to them and I'm sorry. That's all I can say.*

"What do you hope will occur to you, Jack, at the hands of the jury?"

"Mr. Brown, I want only that the truth be known and nothing else, with the hope that in some way I could do something to make up in some way for all the wrong I have done in my life, but I accept whatever the jury decides. I accept whatever this court decides, and I expect nothing but to be treated by the law."

At this point Jack Allen was in tears on the witness stand.

Mr. Brown turned to Solicitor Summerford and said, "Your witness." The first question the solicitor asked Allen was, "Mr. Allen, you did kill Mrs. Nancy Amaker, no question about that, is it?"

"No, sir, there is not."

"Your statement is that you didn't mean to do it?"

"That's true, sir."

After only brief questioning, Allen said, "Mr. Solicitor, I am not attempting to hide, avoid or in any way defend my actions, and if you would like I will plead guilty now to a charge of killing Nancy Amaker. If you want to prove in any way that anything that I have said was a lie, you may do that."

The solicitor continued his questioning, telling Allen, "I am going to prove that a lot you said was not true. When was your first armed robbery?"

"In Detroit, Michigan, when I was on escape in 1966."

"Was that when you took your first hostage?"

"Yes, sir."

"How many times did you commit armed robbery and take hostages?"

"Twice."

"Only twice, is that including the one that you took in St. Matthews?"

"No, sir. It is not."

"So it was three times that you have committed armed robberies and taken hostages?"

No, sir. When I took Mrs. Amaker, I had gone in the store with the intention of committing an armed robbery, not a kidnapping, but I abandoned that. I did on two other occasions prior to that commit armed robberies and take hostages. The first occasion was in 1966. As I testified earlier, I robbed a bar in Detroit and forced a man to drive me to Toledo, and I let him out in an isolated area. During that same episode, I robbed a man in Toledo and took him hostage and released him in the country. I did not state this before to cover it up. I was not charged with it or convicted of it. I just simply failed to state it, but it is true, and I make that admission to you now.

"Well, did you undress either of them?"

"No, sir, I did not."

"In fact, Mrs. Amaker was the first one you had ever undressed, wasn't it?"

"Yes, sir."

Summerford questioned Allen in depth on his criminal history. Allen continued to answer with his lengthy details. When the solicitor questioned Allen on his written statement, Allen said that the words in the statement were not verbatim to what he said.

Allen kept saying that he was in an "alcoholic fog" and didn't remember everything that he did the day that he ended up in St. Matthews. "I did

remember wanting to find a bank to rob but got disoriented and went in the wrong building and took Mrs. Amaker because I thought she had seen my gun, and I didn't want her to call the police."

"Didn't she tell you, Mr. Allen, that she had two little children at home and please don't kill me?"

"No, she uh…mentioned at some point in the conversation that she was a mother."

At this point Solicitor Summerford put a photo of Mrs. Amaker and her two children in front of Allen and yelled, "Is this the lady you killed, Mr. Allen?"

With shaky hands, Allen covered his eyes and backed away.

Mr. Brown interrupted, "Your honor, he has admitted he killed Mrs. Amaker. Solicitor had all the time in the world to introduce that photograph of deceased and two children, and we think this is another one of the low blows that solicitor is trying to pull."

Judge Gregory said, "Well, he may answer. He may look and answer."

Allen replied, "Your Honor, I've tried to be very honest, very truthful, about everything that I've said, but from this point on, I refuse to answer any more questions. I don't want to look at any pictures. I know what I did. I am sorry for what I did. I admit what I did, and I'm not going to lie about what I did. If you want me to answer questions, then I will answer questions, but I don't want to see any more pictures."

"OK, Mr. Allen, didn't she ask you numerous times if you were going to rape her or kill her?"

"Yes, sir."

"And then you take a loaded .38 gun, and you put it to her head?"

"Yes, sir, but not to hurt her. The gun was in my hand, and I reached up to push her down and the gun discharged. It wasn't pointed at her head."

"Mr. Allen, do you deny that you made Mrs. Amaker take off her clothes, made her get back in that car, and she, in the nude, was hysterical, putting her hands to her face. Then you took that gun with your right hand and placed it against her head and told her to hush, and if she didn't, you would kill her?"

"I deny that."

"You deny that, but do you deny, Mr. Allen, that that nude woman was hysterical because she thought you were going to rape her?"

"I don't deny that."

"Isn't it true, her being nude, that she was covering herself up with her hands in her face begging you all the time not to take her life, and you took that .38 gun and placed it right back there to the back of her head?"

"No, sir."

Solicitor Summerford continuously challenged Allen on the truthfulness of his testimony in the state's attempt to prove that Mrs. Amaker's death was a deliberate and premeditated murder, but Allen never wavered in his testimony of saying that he did not intentionally kill Mrs. Amaker.

After two and a half hours of cross-examining Mr. Allen, the solicitor had no more questions. The defense rested.

Following a recess, closing arguments began. Solicitor Summerford said that the state was asking for the death penalty in this case under the new statute that had been in force in South Carolina since the governor signed it in July 1972. "It is required of me as your solicitor to give you my opinion of the law. It is not my responsibility to charge you with the law. The court will charge you with the law."

Summerford went through each section of the statute and gave his opinion of how the state had met all the elements showing that Jack Allen kidnapped and murdered Mrs. Amaker and how it was willful, deliberate and premeditated.

"The burden is on the state of South Carolina to prove this defendant guilty of the crime of murder beyond a reasonable doubt. We feel that we have gone forward with that burden of proof. I have given you my opinion of the law. I will be back and discuss the facts after the conclusion of the defense arguments."

Allen's attorneys addressed the jury, saying,

Jack Allen, the defendant in this case, at your hands lives or dies. He is charged with the crime of murder, the killing of Nancy Amaker on that summer night in August. He did do it. He has from the beginning admitted that he killed Nancy Amaker. He even said that he would plead guilty to that crime. You saw that he could not look at the picture of Mrs. Amaker and her children. Regardless of what happens to Mr. Allen today, he will live for the rest of his life with the guilt inscribed upon his soul that he did take that young lady's life…that she is now dead, but he also said that the killing of Mrs. Amaker was not premeditated but a tragic mistake.

Solicitor Summerford ended arguments giving the jury the reasons he was going to ask for the death penalty.

How many times has this man been in and out of prison? How many times has this man escaped and then went back in prison? This man could not be rehabilitated. He had to live the life of crime. He took his own choosing and made his life for him. I would have had consideration for this man under these circumstances, but what did he do after he put a bullet through the head of Nancy Amaker? He took his gun, he threw it in the river and he didn't stop there. He went on the run and took a gun or the same gun and uses it to rob again and again. Let's talk about sympathy. I have sympathy...for his children more than his wife...she knew all the time what she was getting into. She, too, chose her own life, but members of the jury, if you really want to think about sympathy, think about Mrs. Amaker's husband, a law-abiding citizen...think about her two little children, law-abiding citizens...think about them maybe on Sunday going out and placing flowers on her grave. Let's put the sympathy where it belongs and it is certainly not with that man right there! Now, to the facts in this case, we had nothing to do with the facts. The facts were made by that man right there in his own statement that he made himself that was introduced into evidence. You heard him...when he wanted to use it, he used it. When he didn't want to use it, he said, "They changed my words around...I don't remember what happened." He didn't know what the name of that town was that he went into, St. Matthews...never been to that town before...but he said he was going there to rob a bank...didn't even know if it had a bank...didn't know that most small-town banks closed on Wednesday afternoons. He says, "I got confused, I went into the department store thinking it was a bank." Then he says he starts to reach for his gun and Mrs. Amaker saw it and that's why he kidnapped her because he thought she would go to the police. Let's think about Mrs. Amaker...the joy she must have had in her heart going in and picking up two new dresses for her birthday. She was going to her parents' to her birthday supper that night. That must have been a good day for her...completely innocent. This man didn't let her go to her car...he didn't let her go home and try on those new dresses. He didn't let her go to her birthday supper. He puts her in his own vehicle. Mrs. Amaker certainly did not want to go with him. His own testimony

is uncontradicted. Then he gives officers exact directions to where he shot Mrs. Amaker and to where he put her body. He described it perfectly. The mother of those two little children was told on that night, dark as it was, to get out the car and undress. He didn't tell her he saw a light...just to get back in the car. Ladies and gentlemen of the jury, what would you assume if you were under the same circumstances...in the nude, on the passenger side of the vehicle, and you had been placed there by gunpoint? Think, too, about the angle of the bullet. The barrel of that gun had to be right up against the back of her head according to Dr. Conradi. Did you get that? Now he tries to tell you that he reached over to pull her back into the car, because she was trying to get out the window...he thought. I've been in this business for twenty-four years, and I'll be doggone if I'm that gullible, and I don't believe you are either. That man intentionally put that gun to her head, and he pulled the trigger. He's getting a fair trial, but on that day, August the twenty-first, he acted as a grand jury. He returned a true bill of indictment against Nancy Amaker. After that true bill was given, he acted as the prosecutor, he acted as the jury, he acted as the judge, and more important than that, by gosh, he acted as the executioner. In conclusion, I say to you, this man right here wasted a good human life. He took the life of the mother of two children. You think about that. It makes my blood boil. His confession in his own words was his facts, and the evidentiary weight of his confession must be determined by you the jury. Bring in a verdict that speaks the truth. That's all we ask for. Thank you.

Judge Gregory announced that it was seven o'clock, and because there had been three full days of testimony that had run into the late hours every night, he would adjourn court for the day and resume the next morning with his charge.

On Saturday morning, March 8, Judge Gregory addressed the jury.

Madam foreman and ladies and gentlemen of the jury, it is my duty as presiding judge to charge you with the law applicable to this case. The state of South Carolina charges the defendant, Jack Leland Allen, with murder. The indictment reads in part that Jack Leland Allen did with malice aforethought and in a willful, deliberate and premeditated manner, in Florence County on or about the twenty-first day of August,

1974, kill one Nancy Amaker, by means of shooting the said Nancy Amaker with a gun while committing the crime of kidnapping, larceny or robbery while armed with a deadly weapon. And that the said Nancy Amaker did die in Florence County as a proximate result thereof on or about the twenty-first day of August, 1974, against the peace and dignity of the state. The defendant, Jack Leland Allen, has entered a plea of not guilty. The burden is on the state of South Carolina to prove the guilt of this accused beyond a reasonable doubt before this defendant can be convicted.

He defined reasonable doubt as a substantial doubt arising out of the evidence or lack of evidence in the case, and it is a real doubt for which you can give a reason. He defined murder as the killing of any person with malice aforethought (evil intent), expressed or implied, and in order to convict the defendant of murder, the state must not only prove that the defendant killed the deceased but that there was also the element of malice aforethought.

Under the new death penalty statute which the South Carolina Legislature adopted July 2, 1974, murder committed while in the commission of one of these crimes, kidnapping, robbery while armed with a deadly weapon, larceny with use of a deadly weapon, carries the death penalty. Likewise, murder that is willful, deliberate and premeditated carries the death penalty. Murder under other circumstances carries life imprisonment.

Now there is involuntary manslaughter. Manslaughter is the unlawful killing of another without malice expressed or implied. Murder is the unlawful killing of another with malice expressed or implied. The absence of malice is what distinguishes manslaughter from murder. Manslaughter is involuntary or unintentional when one causes the death of another by some unlawful act, without the intention to take life. One found guilty of involuntary manslaughter would be sentenced by a presiding judge to serve not less than three months, nor more than three years.

Judge Gregory presented the jury with the possible verdicts to consider for Jack Leland Allen, depending upon their view of the evidence:

(1) Guilty of murder committed while in the commission of kidnapping, robbery while armed with a deadly weapon, larceny with the use of a deadly weapon, all or any combination of these; (2) Guilty of murder that is willful, deliberate and premeditated; or guilty of murder with the combination of one or more or all of these specified. Should this defendant be found guilty of murder under any of these circumstances, or a combination thereof, it would be the duty of the trial judge to sentence this defendant to death by electrocution; (3) Guilty of murder under other circumstances not included in the category, he would then receive a sentence of life imprisonment at the hands of the trial judge; (4) Involuntary manslaughter as I have described it. He would be sentenced by the trial judge to serve not less than three months, nor more than three years; (5) If the state has failed to satisfy you of the guilt of the defendant of murder under any of the circumstances that carries the death penalty, or murder under the other circumstances that carries life imprisonment or involuntary manslaughter, then you could find him not guilty, and he would be acquitted of the offenses contained in the indictment. The verdict of the jury is the verdict of all twelve jurors. It has to be a unanimous verdict. It will be that verdict that speaks the truth, giving to this defendant the benefit of every reasonable doubt on each and every issue in this case.

The jury retired to the jury room at 10:40 a.m. After an hour and twenty minutes, the jury returned with its verdict. It was published by the clerk of court. "*The State v. Jack Leland Allen*, indictment for murder; Verdict: Guilty of murder committed while in the commission of kidnapping that is willful, deliberate and premeditated."

Allen's expression did not change when the clerk of court read the verdict. His wife broke into tears, and he reached back and took her hand.

Judge Gregory advised that he would impose sentence for Mr. Allen on Monday. The jury was dismissed and court was adjourned for the weekend.

On Monday, March 10, 1975, Judge Gregory addressed Jack Allen and asked if he had anything he would like to say before he passed sentence. Allen did not.

Judge Gregory read the sentence imposed by law:

The State v. Jack Leland Allen. *The sentence of the court as fixed by law is that you, the prisoner at the bar, Jack Leland Allen, be conveyed*

hence to the county jail of the County of Florence and there be kept in close and safe confinement until you shall be thence conveyed to the state penitentiary, there to be kept in close and safe confinement until Tuesday the twenty-second day of April, nineteen seventy-five, between the hours of six o'clock in the forenoon and six o'clock in the afternoon, upon which day and between which hours you, the prisoner at the bar, Jack Leland Allen, will suffer death by electrocution in the manner provided by the laws of the State of South Carolina. May God have mercy on your soul.

Allen remained quiet as the sentence was read. He was led from the courtroom in handcuffs and chains, passing by his wife as he exited the room. Allen's attorneys immediately filed a Notice of Intention to Appeal that same day, March 10, 1975, which automatically stayed Allen's execution.

Jack Allen was not brought to trial in Calhoun County for the kidnapping of Nancy Amaker. In 1975, the South Carolina Code of Laws, Section 16-52, stated that whoever is guilty of murder while in the commission of certain crimes and acts shall suffer the penalty of death. Kidnapping was one of the crimes. So there was no trial for kidnapping, since he was already under a death sentence for murder.

In February 1976, the South Carolina Supreme Court reviewed Allen's case and found no merit to any of the arguments to overturn the verdict. The death sentence of Jack Allen was upheld.

But Jack Leland Allen will never be put to death in South Carolina for the murder of Nancy Amaker.

In July 1976, the South Carolina Supreme Court made a decision that the state's death penalty was unconstitutional and did not meet the United States Supreme Court's guidelines. This resulted in all South Carolina death sentences between 1974 and 1976 to be commuted to life in prison.

On September 22, 1976, Jack Leland Allen's new sentence of life in prison was handed down by Judge Dan E. McEachin in Florence County. A life in prison sentence also carried the possibility of parole eligibility.

In a CBS *48 Hours* broadcast in 1987, focusing on the problem of overcrowded prisons, "The Case of Jack Allen" was one of the cases reviewed. Allen was portrayed as a model prisoner. "He does not fit the stereotypes. He is the chairman of the Inmates Advisory Board. He is smart, articulate…and a convicted killer. He has spent twenty-eight of his forty-seven years behind bars, and he is up for parole for the fifth time."

The reporter asked Nancy's husband, Buddy, "How much punishment do you think is enough for him?"

Buddy replied, "The rest of his life behind bars would suit me. I don't think he can be in society without the potential of that same thing happening again. I don't want anybody else to go through what we went through."

The reporter told Allen, "You have wrecked their family's life, and to the fullest extent, you have wrecked your own family's life."

Allen nodded. "And I am so sorry. I'm not the same Jack Allen that I was back then."

Buddy commented, "I'm sorry, too, that the whole thing happened…sorry that he was born with the ability that allowed him to take a life."

Buddy turned to his and Nancy's daughter, Cathy, who was then nineteen years old. "I wish she could be here to see you start college."

Cathy replied, "I missed out on so much not having my mother. I feel like he has to pay for what he's made me miss out on."

Allen's attorney told the reporter, "It's a challenge for me to take his case. I'm doing what is in his best interest, and, quite frankly, what's in my best interest. I'm getting a certain amount of fulfillment out of my practice of law."

To which the reporter replied, "Well, I'm sure those people will say good for you, but are you doing what is in the best interest of the woman he killed?"

He answered, "With all respect to them, I don't represent them. I feel as sorry as I can for them, and the remorse that Jack Allen feels for them is true remorse, but they're not my clients. Jack Allen is my client, and I'm going to do everything I can to move him through the system."

During the hearing, Jack Allen spoke: "If I'm paroled, I will go to the federal system. Jack Allen will probably never be free to walk the street again. If you parole me, I can be nearer my family…in an institution closer to home where I can see my family. What I'm asking you to do is to let me go home and love my children a little bit. I want to get on with my life. I want my family to get on with their life, and I want the victim's family to get on with their life. Let it be over with."

Jack Allen was taken from the room.

The family spoke: "Prison seems to have no effect on him. He was on parole when he killed Nancy. If he is put in the federal system, we're afraid he will get back out and do again what he did to Nancy. We certainly feel that he has had his mercy by being spared the death penalty."

Jack Allen was again denied parole by a unanimous vote of the South Carolina Probation, Parole and Pardon Board, and he remains incarcerated at the South Carolina Department of Corrections. But parole is a reality. We are condemned to that. Every two years the family of Nancy Amaker receives a letter from the Probation, Parole and Pardon Board informing them that Jack Leland Allen is up for parole. The Amaker family attends every parole hearing to plead their case that Jack Allen should not be let back out. At first they were in the same room and right next to the man who killed their wife, mother, sister and friend. Later Jack Allen was televised into the room.

Through the years, Allen's parole has always been rejected.

On August 27, 2008, I was present at Jack Allen's parole hearing along with family and friends. He was again denied parole. In two years, he will be eligible again.

Nancy's mother died in 1978, four years after Nancy was murdered. Her father died in 1987. Her husband, Buddy, died in 1998.

MURDER OF JOYCE ROBINSON

Sumter, South Carolina, 1989

Joyce Robinson was engaged to be married to South Carolina state trooper Emanuel Johnson in November 1989. Family and friends say that she glowed as she planned and talked about her upcoming wedding. She had already bought her wedding dress and was ecstatic about being married and having a family of her own.

Ms. Robinson lived alone in a duplex house on Baker Street in Sumter, South Carolina, which neighbors say was a "normally quiet and pretty good little neighborhood." City residents would say, "Sumter is a place and community we love to call home. Being located in the middle of South Carolina, we have the beautiful beaches in one direction and the Blue Ridge Mountains in the other. Although it is the eighth largest city in South Carolina, it is still a city with a small-town feel."

Ms. Robinson's fiancé, who lived in Columbia, about fifty miles away, had been trying to call her all day and up into the late evening hours on Monday, April 24, 1989. He became extremely concerned when he did not get an answer after midnight, so he called a friend to go check on her. The friend went to Ms. Robinson's home. She went to the side door and saw what she thought was blood smeared on the exterior of the door. She knocked on the door but did not get a response. She left and went to the Sumter Law Enforcement Center and reported what she had observed. Sumter Police officers arrived at Ms. Robinson's home about 3:20 a.m., Tuesday morning, April 25. They saw the blood smear on the side door and looked through

Joyce Robinson. *Courtesy of Anthony Robinson.*

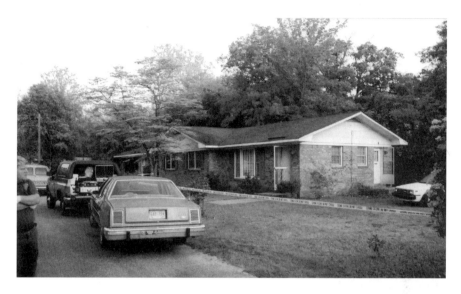

Above: Joyce Robinson's duplex home on Baker Street. SLED agent Ira Jeffcoat is at left. *Courtesy of SLED.*

Below: Blood smears on the side door of Ms. Robinson's home. *Courtesy of SLED.*

the window of the door. The television was on and the room was in total disarray. Proceeding with caution, they opened the door slightly. They could see a blood-soaked hand, and when they opened the door fully and continued inside, they saw the body of a black female on the floor of the kitchen near the door. Her body was covered in blood. She had been stabbed multiple times and beaten severely around the head. Her throat was slashed almost to the point of decapitation.

Sumter Police contacted the South Carolina Law Enforcement Division (SLED) for assistance. SLED resident agent in Sumter Perry Herod, along with the SLED crime scene team—Agent Jim Springs, Don Grindt and Ira Jeffcoat—responded. Sumter County coroner Bill Gamble arrived at the scene and pronounced the victim dead at 4:40 a.m.

SLED bloodhounds were brought in to search the area, but the search proved fruitless. SLED investigators spent all day Tuesday at the crime scene assisting Sumter Police investigators with searching and collecting a large amount of evidence. Blood was found all over the apartment: on the inside of the front door, the wall by the front door, the television, couch, clothing on the couch, coffee table, wash basin stand in den, vacuum cleaner near the wash basin, wall behind the wash basin, telephone, refrigerator, dishwasher door, kitchen drawers, kitchen walls, window blinds, kitchen table and table legs, paper articles on the kitchen table, iron and ironing board cover, exerciser, walls, doors, doorknobs, bedsheets, bedspread, bed ruffle, towels in the bathroom including a wet, blood-soaked towel in the bathroom sink, bathroom counter top and in and around the bathroom sink and bathtub.

Blood spatter patterns were found in the hallway, which showed distinct changes in direction indicating that the victim struggled with her attacker(s) in an effort to defend herself. Dripped blood patterns (blood drops) were found throughout the duplex in all rooms. Blood drops found in Ms. Robinson's bedroom and closet indicated that the suspect(s) rummaged through her bedroom and closet. Clothing was strewn about, with blood being dripped on successive layers of clothing. At the foot of Ms. Robinson's bed was her black patent leather pocketbook. On the pocketbook was a bloody fingerprint. Blood was also found on the inside flap of the pocketbook. A bloodstained serrated kitchen knife, a bent fork and a blood-covered broomstick were found near the victim's body.

Latent finger and palm prints throughout the house were photographed and lifted (by applying clear lift tape firmly over the print, the print

Bloody towel found in Ms. Robinson's bathroom sink. *Courtesy of SLED.*

Ms. Robinson's black patent leather pocketbook at the foot of her bed. *Courtesy of SLED.*

adheres to the tape to permanently record the print). A partial shoeprint impression in what was believed to be the victim's blood was located on the exterior brick steps leading from the kitchen area of the victim's residence. The shoeprint impression was photographed in place, and the bricks with the shoeprint impression were removed intact and transported, along with all of the other evidence, to the SLED forensic laboratory for further analysis.

Neighbors of Ms. Robinson told officers that it was usually quiet down on that end of Baker Street, and they did not hear or see anything out of the ordinary on Monday night. They were shocked and afraid because nothing this horrible had ever happened in the area before.

Joyce Robinson was twenty-nine years old. She and her bother, Anthony, were raised by their aunt and uncle, Hercules Sr. and Albertha Garrick, after their parents separated and later divorced when they were very young. They had lived in Sumter all their life. Joyce graduated from Sumter High School in 1977. She attended Columbia College, graduated in 1981, came back home to Sumter and began working for the Citizens and Southern Bank. She served as a teller, then assistant branch manager and later was promoted to branch manager. She later accepted a position as a field representative for Philip Morris Tobacco Company. She was well known around Sumter. She was very outgoing, honest and trustworthy and was involved in many community projects.

Joyce's brother, Anthony, lived right down the street from Joyce. About 5:30 a.m. that Tuesday morning, Anthony was awakened by his brother, Hercules Jr., banging on his door and yelling, "Wake up, somebody killed Joyce." They rushed to Joyce's duplex and saw all the police cars and yellow tape surrounding the area. When Anthony walked toward the door and saw the blood on the outside, he passed out. When he came to, he could not believe what had happened to Joyce. He just kept saying, "How could somebody just kill somebody like this? Everyone that knew Joyce loved her. She always worked hard, cared about others and had a smile for everyone. She was a good person and a good sister."

An autopsy was performed on Ms. Robinson later Tuesday at Tuomey Hospital in Sumter. Preliminary results confirmed that she died from a long, deep cut to the throat. There were numerous cuts and bruises on her face and other areas of her body. Cuts on both hands indicated that she struggled with her attacker to fend him off. Cuts and wounds to her body

were consistent to the serrated knife found next to her in the kitchen. No wounds were consistent with the bent fork found near her body.

Investigation continued. Ms. Robinson's sales route for the Philip Morris Tobacco Company was checked out. She was last seen alive at one of the stores on her route about 4:00 p.m. Monday, and she did not show up for a manicure appointment that was scheduled later that day. It was not known if Ms. Robinson was killed by a stranger or someone she knew. Law enforcement had no suspects, but with the amount of evidence that was collected from the scene, they were hopeful that a break would come soon.

SLED serologists worked diligently with the blood evidence from the scene. Test results proved that there were two bleeders at the scene. The victim's blood type was B. The other blood evidence was type O. This indicated that Ms. Robinson's attacker was also injured, and because of the momentous amount of type O blood found at the scene, the attacker's injury would be significant, possibly to the point of needing medical attention. Sumter Police checked all hospitals in the area for anyone who might have been treated for any serious cuts or injuries. None were found.

Joyce Robinson's funeral was held on Friday, April 28. She was buried in the wedding dress that she would have worn six months later to marry South Carolina state trooper Emanuel Johnson. Fellow South Carolina state troopers stood with their hats over their hearts as pallbearers passed by carrying Ms. Robinson in the cemetery.

With the belief that the murderer might attend Ms. Robinson's funeral, law enforcement officers were present. They stood ready for anything out of the ordinary. Observation photographs were taken of persons who attended. Cars and license numbers were documented.

The bloody fingerprint on Ms. Robinson's black pocketbook was a major piece of evidence. SLED fingerprint examiners determined that the fingerprint was not Ms. Robinson's print. Serology analysts determined that the blood in the fingerprint was not Ms. Robinson's blood. With almost certainty, this indicated that the fingerprint and the blood belonged to the suspect.

Close-up and specialized photography were used to photograph the bloody fingerprint in order to capture the fingerprint with the highest quality possible and to bring out as much detail in the print as possible. There were no suspects. The negatives and photographs of the bloody fingerprint were placed in the case file.

South Carolina state troopers stand in line awaiting Joyce Robinson's body at the cemetery. *Courtesy of SLED.*

Bloody fingerprint on Ms. Robinson's pocketbook *Courtesy of SLED.*

In 1989, to determine a positive fingerprint match, the questioned print (crime scene evidence) had to be compared to the known print of a suspect. There had to be a suspect, and the suspect's known prints had to be available. In this case, the latent print on the pocketbook was of poor quality, but SLED fingerprint examiners believed it to be identifiable if compared to the known suspect's print.

The Automated Fingerprint Identification System (AFIS), a database of fingerprints, palm prints and demographic data in which unknown prints can be entered for a possible match, did not exist in 1989. The South Carolina Law Enforcement Division had begun the process of converting all of South Carolina's fingerprint files for automation but did not operationally go online until the late 1990s.

Five days into the investigation, Sumter Police and SLED had no leads to a suspect. Then came a possible break. On Sunday morning, April 30, twenty-eight-year-old Henry Mack Singletary called the Florence Police Department about 8:30 a.m. He told Captain Waymon Mumford that he wanted to turn himself in for killing Joyce Robinson. When officers arrived to speak to Singletary, he changed his story and told them, "No, I thought I was just wanted for questioning about the murder. I just wanted to say that I was in the Baker Street area last week when she was killed, and I thought I saw somebody running away from her house. When I heard about her murder, I thought he might be the killer, and I was scared for my life."

Florence and Sumter Police questioned Singletary for several hours. He never admitted to the murder but never specifically denied it. Officers were not sure whether he was telling the entire truth, as he seemed to be talking in circles sometimes.

As indicated from the blood evidence at the scene, Robinson's attacker had received significant injuries. Singletary did not appear to have any recent visible injuries or scars.

The next day, Monday, May 1, Henry Mack Singletary was arrested for the murder of Joyce Robinson.

Family members of Singletary told officers that he worked off and on as a roofing laborer and did odd jobs around the Sumter area. They also told officers that they weren't sure if he knew Joyce Robinson, as they had never heard him speak of her. They knew that he had been in trouble with the law before and sometimes "his mind would flip" and he would act confused.

Most folks who knew Singletary knew him as being humble and never causing any trouble with the people for whom he worked. They could not believe that he would do something like this, and some wondered if the right person had been arrested.

Even though there was an arrest, officers still encouraged anyone who might have helpful information to contact the Sumter Police Department or SLED.

Rumors began spreading that several well-known persons were being blackmailed in connection with the case, and a prominent area businessman had been arrested. Also, Ms. Robinson's home was a target of a prostitution probe. Major Joe Floyd of the Sumter Police Department reported that there was no substance to any of the rumors.

The *Item* reported that on Thursday, May 4, as Singletary arrived at the courthouse for his bond hearing, he was crying and refused to get out of the car, but with just a little assistance he exited the car. During the hearing, he appeared frightened and hid under a table and screamed to Judge McInnis, "I want to tell you about the whole thing." The courtroom was cleared. Singletary started yelling at his attorney and again at the judge. Singletary was escorted back to the Sumter County Correctional Center. No bond was set, and he was ordered to undergo a mental evaluation. A physical evaluation was also ordered to determine if he had any inflicted injuries that might have happened during the attack.

On May 5, Singletary was admitted to the state hospital in Columbia, South Carolina, to undergo a psychological evaluation. Since Singletary had no visible signs of injury, Chief Public Defender Arthur Wilder was also granted a request for Singletary to undergo a complete physical examination.

Evaluation results from the state hospital showed Singletary to be paranoid, schizophrenic and mentally ill and, at this time, not capable to stand trial. The doctors asked for another fifteen days for evaluation and were confident that his condition could improve with additional treatment. Singletary remained in the state hospital, and at the end of this period of treatment, he was reported to be competent to stand trial. His physical examination showed no signs of injury that might be related to the attack.

A fingerprint comparison was performed by SLED Agent Jim Springs of Henry Mack Singletary's known prints to the bloody print on the pocketbook

from the crime scene. The fingerprint was not a match to Singletary. Blood typing of Henry Mack Singletary was performed by SLED Serologist Ira Jeffcoat. Singletary was type O.

The Federal Bureau of Investigation assisted SLED with the DNA testing of blood evidence from the crime scene and known blood from Henry Mack Singletary. The DNA testing used in 1989 was standard DNA testing RFLP (Restriction Fragment Length Polymorphism), sometimes called DNA fingerprinting or profiling. DNA databases were not yet established in 1989, but the DNA profile of evidence from a crime scene could eliminate or identify a suspect if compared to the known DNA profile of a suspect. DNA results proved no match to Singletary.

No evidence at the murder scene was linked to Singletary, and all charges against him were dropped. He was released in August 1989. Two years later, he was convicted of first-degree criminal sexual conduct and sentenced to eighty years in prison.

Sumter Police and SLED stayed busy on the Robinson case around the clock.

The footwear impression on the bricks from the steps of Ms. Robinson's home was photographed at the SLED photography lab. The bricks and the photographs were sent to the FBI for further analysis. FBI results revealed that the footwear impression on the steps was found to be from an Adidas design, but the impression was too limited to enable a meaningful comparison with known shoes. No blood was identified on the bricks bearing the footwear impression.

Over two hundred possible suspects were eliminated by SLED fingerprint examiners based on comparisons of known inked print impressions to latent prints found at Ms. Robinson's home.

The case continued to be under investigation. It was one that officers couldn't get off their minds or out of their hearts. Tips came. Tips went. Some sounded so good...so close to the break they needed. Days, months and years went by. The break never came. The case went cold. All crime scene evidence at the SLED Forensic Laboratory was returned to the Sumter Police Department.

SLED forensic examiners did not forget this case. Agent Jim Springs would say, "This kind of case just gets in your mind and heart and it stays there." They always held onto hope that one day, with the advancements of forensic technology, Joyce Robinson's murderer would be found.

SLED serologist Ira Jeffcoat, one of the first responding investigators to the crime scene in 1989, knew that with all of the blood at the scene they always had a good DNA profile of the suspect, and this case could be solved.

In 1995, local, state and national law enforcement agencies began setting up DNA databases. All three levels contain forensic and convicted offender indexes and a population file (used to generate statistics).

LDIS (Local DNA Index System) is operated by police departments and sheriff's offices. DNA profiles originated at the local level can be transmitted to the state and national levels.

SDIS (State DNA Index System). Each state has a designated laboratory that operates the State DNA Index System. SDIS allows local laboratories within that state to compare DNA profiles. New offenders and casework profiles are continually uploaded and compared to the state database, often generating "hits." SDIS is the communication path between the local and national levels.

NDIS (National DNA Index System) is maintained by the FBI under the DNA Identification Act of 1994. NDIS became operational in October 1998. State agencies upload all new profiles to NDIS. New profiles are compared to existing profiles often generating "hits."

CODIS (Combined DNA Index System) is implemented as a distributed database comprised of LDIS, SDIS, and NDIS. CODIS software enables local, state, and national labs to compare DNA profiles electronically, thereby linking serial crimes to each other and identifying suspects by matching DNA profiles from crime scenes with profiles from convicted offenders.

www.dna.gov

Newly advanced DNA profile testing was now being used to comply with the DNA databases, and with each day and each new entry, the DNA databases continued to grow. Lieutenant Ira Jeffcoat, who had processed the blood evidence in 1989, knew that this could be the potential solution to this case.

In 2004, fifteen years after Joyce Robinson's murder, Lieutenant Jeffcoat contacted the Sumter Police Department and had the original evidence resubmitted to the SLED DNA Lab.

The DNA profile testing used in 1989 of the blood on the blue towel found in the sink in Joyce Robinson's bathroom was not compliant with the

DNA profile testing now required for CODIS, so newly advanced DNA testing would have to be performed on the blood from the towel.

Lieutenant Jeffcoat directed SLED evidence technician Cecil Bradshaw and SLED evidence supervisor Lieutenant Emily Reinhart where to make the blood cuttings from the towel. SLED senior agent/CODIS state administrator David McClure used STR (Short Tandem Repeat)/PCR (polymerase chain reaction) testing to develop a DNA profile from the blood on the blue towel. He entered the profile in CODIS.

In August 2004, a CODIS search returned a potential (similar) match to Earl Mack. A review of this potential match eliminated Earl Mack as a contributor, but indicated a close male relative. As a result of this information, Agent McClure checked the SLED forensic files for additional evidence. He saw that there was an unidentified latent fingerprint from the black patent leather pocketbook found on Ms. Robinson's bed. He contacted Lieutenant Tom Darnell, supervisor of the SLED Crime Scene/Latent Fingerprint Unit, and informed him of the potential DNA match returned from CODIS. Lieutenant Darnell said that the print was poor quality but most probably identifiable if he had a known print from the suspect to compare it to.

Agent McClure contacted Captain David Caldwell in the SLED Behavioral Science Unit to assist in finding any male family members of Earl Mack. Three names with state identification numbers (SID) were found. The SID is an identifying number assigned to the subject of record by the state in which an arrest occurred. Agent McClure delivered these three names as possible donors of biological evidence in this case to Lieutenant Darnell. Darnell retrieved fingerprint cards on all three of these individuals for the purpose of comparing to unidentified latent prints in this case and conducted a fingerprint comparison on all three individuals with the latent print photograph of the bloody fingerprint on the black patent leather pocketbook. He positively identified the bloody print from the pocketbook to the left index finger of Tony Olevia Mack, brother of Earl Mack. It was verified by four other SLED latent print examiners, Senior Agents Steve Derrick, John Black, Diane Bodie and Joe Leatherman.

Lieutenant Darnell also had the black patent leather pocketbook resubmitted by the Sumter Police Department to conduct a visual examination of the bloody fingerprint. He confirmed positive identity of the fingerprint on the pocketbook to Tony Olevia Mack.

L INDEX

Tony Mack's left index fingerprint was matched to the bloody fingerprint on Ms. Robinson's pocketbook. *Courtesy of SLED.*

In August 2004, Agent McClure notified Sumter police chief Patty Patterson, who was a special agent with SLED at the time of Joyce Robinson's death, and informed her of the results of the potential DNA match returned from CODIS and the positive identification of the fingerprint on the pocketbook to Tony Mack.

Sumter Police began investigating Tony Mack. He was a former resident of Sumter, now living in Fayetteville, North Carolina. The Mack family had lived in the same neighborhood where Joyce Robinson's family lived and where all the kids grew up. Police talked with family, friends and acquaintances who had known Mack over the years.

Mack's past arrest records in South and North Carolina showed charges of breach of trust, assault and battery, common law and strong-armed robbery, criminal domestic violence, assault and robbery with deadly weapon and larceny from person.

Sumter Police contacted the Cumberland County Sheriff's Office in Fayetteville, North Carolina, and asked for their assistance in locating Tony Mack. They informed officers that he still had outstanding charges in Sumter for breach of trust and driving under suspension. On Thursday, October 7, 2004, Cumberland County deputies arrested thirty-nine-year-old Tony Olevia Mack. He was arrested without incident.

SLED Agent Valerie Williams and Sumter Police Lieutenant Alvin Holston traveled to Fayetteville and met with Tony Mack. They informed him of the outstanding charges and told him that he needed to come back to Sumter. Captain Holston left the room and called Sumter police chief Patterson. The walls were not soundproof in the interview area and Mack overheard Holston say something about the murder. Agent Williams was in the room with him, and as she describes it, "Mack pretty much lost it." He started banging on the door and yelling, "If you want me to go back to Sumter to fight a murder charge, let's go, 'cause I didn't have anything to do with any murder." Mack waived extradition and was transported back to South Carolina. On the way back, he commented that he did know Joyce Robinson and her brother Anthony. "We grew up in the same area when we were kids, so I knew them when we all got older."

Police Chief Patterson did not have Tony Mack charged with murder until he arrived back in South Carolina on Thursday evening. He was questioned about Joyce Robinson's murder and made some comments and statements, but made no confessions.

Chief Patterson announced Tony Mack's arrest at a news conference Thursday night.

According to an article by Ken Bell, city editor of the *Item*, Chief Patterson reported at the news conference, "Many clues were left behind by the person that killed Ms. Robinson. The evidence was there all along. What changed was the way we looked at it. Advancements in forensic technology made the connections to Tony Mack."

A hearing to advise Tony Mack of his rights was held at the Sumter-Lee Regional Detention Center on Saturday, October 9, 2004. Bond was set for his

Tony Olevia Mack, 2006.
Courtesy of South Carolina Department of Corrections.

outstanding charges. Judge Joe Davis advised him that a bond hearing for the murder charge would be held later. Judge Davis asked Mack if he understood the charges against him, to which Mack answered, "I understand the charges, but I don't understand how I can be charged with first-degree murder."

During an interview, officers asked Mack if he had attended Joyce's funeral, and he replied, "No." Mack kept saying, "I didn't do this. They told me they charged me with murder because of DNA that matched somebody from my family. I'm not happy about how they arrested me and brought all my family into it."

Tony Mack continued to maintain his innocence, even to the point of voluntarily giving a blood sample. Mack's blood was submitted to the SLED DNA Lab for DNA testing. Agent McClure used SRT (Short Tandem Repeat) PCR testing to develop a DNA profile of Mack's blood and a DNA profile from blood on the towel found in Robinson's bathroom.

The DNA profile developed from the towel matched the DNA profile developed from Tony Mack. Agent McClure concluded that the

probability of randomly selecting an unrelated individual having a DNA profile matching the blood from the towel was approximately one in nine hundred trillion.

A DNA profile was developed using (STR) PCR testing from a swab of blood from the black patent leather pocketbook. The DNA profile from the blood on the pocketbook matched the DNA profile of Tony Mack. Agent McClure concluded that the probability of randomly selecting an unrelated individual having a DNA profile matching blood from the pocketbook was approximately one in sixty-six quadrillion. DNA profiles of blood from additional evidence from the crime scene also matched the DNA profile of Tony Mack.

Lieutenant Darnell performed latent print comparisons of prints lifted from around the bathroom sink in Robinson's home to inked print impressions of Tony Mack. They were a match to Tony Mack. The overwhelming forensic evidence matched to Tony Mack could not be refuted.

The Sumter County Grand Jury returned a true bill indictment charging Tony Mack with the murder of Joyce Robinson. Tony Mack remained in the Sumter-Lee Regional Detention Center without bond.

Fingerprints lifted from around the bathroom sink were a match to Tony Mack. *Courtesy of SLED.*

Two years after Mack's arrest in 2004, on Thursday, October 5, 2006, a hearing of *The State of South Carolina v. Tony Mack* was held in Lee County. The change of venue from Sumter County to Lee County was pursuant to an agreement between the state and Tony Mack's defense counsel.

Prior to going into the courtroom, Third Circuit Court Judge Howard P. King conducted a pretrial conference in chambers with Mack's court-appointed attorney, Charles T. Brooks III, Solicitor Kelly Jackson and Sumter County Police Department attorney Martha Horne.

Sumter police chief Patty Patterson, officers with the Sumter Police Department and SLED agents were present in the courtroom. No family members of Joyce Robinson or Tony Mack were at the hearing.

When court convened, Judge King announced, "After discussions with all counsel involved in the matter of *The State v. Tony Mack*, it appears that this matter is not going forward and it will be continued and will be called with the pleasure of the solicitor at another time. The court is hereby imposing an order on all parties involved in this case not to discuss with anyone, the press, public, anyone else, any matters concerning this case because of the possible prejudice for both the defendant and the state when this matter is finally called to trial."

Solicitor Jackson addressed the court, "Your Honor, may we approach?"

After discussion at the bench, Judge King announced that counsel advised that there had been some involvement that might make the matter go forward at this point. "I understand that negotiation discussions have taken place and the parties are prepared to go forward."

Solicitor Jackson replied, "That's correct your Honor."

Judge King reminded all parties that the order that he put on the record was still in effect. "The actual negotiations that went on are part of the legal process in the matter of where we are right now and are not to be discussed with anyone." Judge King addressed Solicitor Jackson.

Solicitor Jackson replied, "Your Honor, the indictment is *The State v. Tony Mack*. It is an indictment for murder. It is my understanding that he wishes to enter a plea of guilty at this time of the murder of Joyce Robinson. It is a negotiated sentence that we would offer up to the court at the appropriate time and also remind the court that he is waiving venue from the Sumter County case to enter a guilty plea in Lee County."

Judge King asked Mr. Brooks if he had informed Mr. Mack that he had the right to have this matter heard in Sumter County, since it is

a Sumter County case, but he could waive that venue issue and the judicial question that was about to be brought today, and in taking the indictment, the possible punishment, his constitutional rights and his right to a jury trial.

Mr. Brooks replied, "I have your Honor and he understands the charges, punishment and his constitutional rights."

Judge King spoke to Mack: "Mr. Mack before I can accept the plea of guilty, it is necessary for me to make sure that your pleading guilty is freely and voluntarily. You've heard your attorney tell me that he has explained to you the charge against you and the possible punishment and your constitutional rights and that you understand these things. Is that correct?'

Mack asked, "Punished about what though, your Honor?"

Mr. Brooks conferred with Mack, and Mack replied back to Judge King, "OK, yeah."

"Then you do understand the charges?"

"Yeah."

Judge King called counsel to the bench, which resulted in Judge King explaining to Mack, "The indictment in this case, returned by the grand jury of Sumter County, is just the accusations only, because that is what an indictment is; it's simply an accusation. It says that in Sumter County on or about April 25, 1989, you did feloniously, willfully and with malice or forethought, either expressed or implied, kill one Joyce Robinson by means of stabbing her multiple times and that she died as a result of those injures. The charges are going to confer. I ask you now, Mr. Mack, do you understand the charge?"

"Yes, I understand the charge."

"All right, and do you understand that for this offense you could get up to life in prison and that would be the maximum punishment?"

"Yes."

Mr. Mack, when you plead guilty you give up certain important constitutional rights. First, you give up your right to remain silent, your right to say nothing at all. You cannot be compelled to testify or provide evidence against yourself. Second, you give up your right to have a jury trial, and you do have the right to have a jury decide whether or not you are guilty beyond a reasonable doubt. The jury must base their decision upon evidence which the state presents and on any evidence

of which you might wish to introduce. In a trial, you are presumed to be innocent, and the state would have to produce evidence that would have to convince all twelve members of the jury of your guilt beyond a reasonable doubt. Third, you would give up your right to see, hear and cross-examine the witness that may be called against you during the trial and the right to call witnesses on your behalf. Do you understand these constitutional rights?

"Yes."

Judge King told Mack,

Before I call on you to hear a plea in this case, I want to tell you that the sentencing sheet given to me indicates that this is a negotiated sentence between your lawyer and the state's lawyer. That means that your lawyer and the state's lawyer have entered into negotiations and have decided what your sentence in this case will be as far as what the court can impose. If I cannot accept the negotiations as put on record by Mr. Jackson and Mr. Brooks and agreed to by you, I would allow you to withdraw your plea. Do you understand that?

"Yes."

Judge King asked Mr. Jackson to tell what the negotiations were.

"Your honor, there are two issues that were negotiated. First was the amount of sentence. Mr. Mack was offered a plea to a negotiated thirty-year sentence. The thirty-year sentence was acceptable to the state and it is also acceptable to the Sumter Police Department. Second, there is a breach of trust case from December 1996, and the state will not process that case upon his enter of a plea of guilty in this case."

Mr. Brooks agreed with the negotiations and added, "And of course Mack would get credit for the two years' time he has already served."

Judge King replied, "OK, the negotiations are a thirty-year sentence with credit for time served and the dismissal of the pending breach of trust case."

Solicitor Jackson and Mr. Brooks agreed.

Judge King wanted to make sure that Tony Mack agreed with the negotiations as put on record by the solicitor. He repeated them to Mack and added, "And whatever parole eligibility that there may be." He informed Mack that he could not advise him what his parole eligibility would be. The

final analysis for parole would be up to the South Carolina Department of Parole.

Mack replied that he understood, and he agreed to the negotiations.

Judge King asked Mack again, "Understanding the nature of the charge against you, the negotiations, and the fact that I will allow you to withdraw your plea if you cannot go along with the plea after I hear the facts, I would ask you again, how you plead to this charge, guilty or not guilty."

"I plead guilty your Honor."

"Do you understand that when you plead guilty, you admit the truth to the charge against you?"

"Yes."

"And, you're pleading guilty of your own free will and accord because you are guilty?"

"Yes."

"Do you have any complaints that you want to make about your lawyer, the solicitor or any of the police officers?"

"I'm just concerned about the way they went about changing the way they charged me. I'm suppose to get thirty years…suppose to carry involuntary manslaughter. They went to murder with that…"

Judge King replied, "Well, that's the state's choice. The state has the right to charge you with whatever they think is appropriate. You may not agree with that, but they have the right. Do you understand?"

"So, they got that right?"

"Yes, they have the right. Now, Mr. Mack, have you understood my questions?'

"Yes."

"Is there anything that you would like to add?"

"No."

Judge King advised Mack that he had the right to appeal his guilty plea and the sentence of the court and that it must be done within ten days. Next he asked Mr. Jackson if the victim's family was represented in the courtroom because, under the Victims Rights Bill, they have the right to be advised of everything that is going on and the right to be at the hearing and address the court if they would like.

Mr. Jackson replied, "The victim, Joyce Robinson, has a brother named Anthony Robinson. I met with him and informed him of this case and the potential plea. He did not wish to be here. He is waiting on the results of

the plea, and I will call him and go by and see him this afternoon. He was notified, and I did discuss this with him."

"They have chosen not to be here, so we can go forward. Mr. Jackson will you give the facts and the background, please?"

Mr. Jackson informed the court that Chief Patterson and the other officers present had selected Attorney Martha Horne to tell the court the facts of the case.

Mr. Brooks spoke, "Your Honor, my client has an objection. It was his understanding that Solicitor Jackson would be the one reciting the facts and basically all this is throwing him off and that is his objection."

"I understand the objection, Mr. Mack, but Ms. Horne is a lawyer and she is an officer of this court. She is not law enforcement, and she has the right to appear before this court and present the facts. Go ahead, Ms. Horne."

Ms. Horne advised the court that Lieutenant Alvin Holston with the Sumter Police Department and SLED Agent Valerie Williams, primary investigators on the case, were present in the courtroom. Also, SLED Agent David McClure was also present if the court had additional questions about the DNA and CODIS process.

Ms. Horne gave a brief synopsis of the events that led police to the home of Joyce Robinson the morning of April 25, 1989, and details after they entered the home and discovered that Ms. Robinson had been stabbed and killed. She continued,

> The house was covered with blood. The autopsy report uses terms such as severed and saw-like in describing the numerous wounds to Ms. Robinson's body. We have photographs if the court would like to see them. In the course of processing the scene, numerous items and blood were collected. What proved to be the critical items were a blue towel in the bathroom sink and a bloody fingerprint on a pocketbook in the bedroom. From the beginning in 1989, officers knew they had sufficient evidence to identify the person who killed Joyce Robinson. However, there was no one to match the evidence with at that time. There were fingerprints and there was blood that did not belong to Ms. Robinson found in the house. The bloody fingerprint on the pocketbook and fingerprints found near the bathroom sink both match the defendant. The blood on the blue towel and the pocketbook also matches the defendant. Over the years with advances in forensic technology, the DNA CODIS system recognizes relatives to

a certain degree, and during a search in 2004, it returned a hit on an inmate who is the defendant's brother. The defendant's fingerprints were found to be on file with law enforcement, and the bloody fingerprint on the pocketbook and the fingerprints on the sink were a match to the defendant. From there, further inquiry was made, and during the process, the defendant agreed to give a blood sample. DNA of Tony Mack's blood was a match to the blood from the crime scene.

Ms. Horne told Judge King that in her twenty-five years plus of working with cases, this was one of the most severe crime scenes she had ever seen. "I do believe that this is the closure that our community and those who were friends and family of Ms. Robinson have been waiting for all these years."

Judge King asked, "What was the DNA probability?"

Ms. Horne offered SLED Agent McClure to give that information. Agent McClure testified that the probability of randomly selecting an individual having a DNA profile matching those items of blood from the crime scene was approximately one in sixty-six quadrillion.

Mr. Jackson presented the court with Tony Mack's prior records. His South Carolina records consisted of the following: in 1988, assault and battery in violation of a rental agreement in Sumter; in 1997, a criminal domestic violation conviction in Sumter; and, later in 1997, a strong-armed robbery in Florence. In 1992, he had a conviction in North Carolina for assault with a deadly weapon and received a ten-year sentence.

Judge King advised that there was substantial factual basis for this plea, and the defendant's guilty plea was freely, voluntarily, knowingly and intelligently made. "I've heard the facts from the state, but I have also been involved with Mr. Brooks, Mr. Jackson and Ms. Horne in chambers with discussions regarding the negotiated plea and negotiated sentence. The court is going to accept the plea and the negotiated sentence due to the length of time that this case has been pending and other matters that we discussed."

The judge asked Mr. Brooks when Mack was arrested for purposes of credit time served.

"He's been incarcerated in the Sumter County Detention Center since October 7, 2004."

King then asked Mack if he had anything he would like to say to him. Mack held out his hands and shook his head.

"I'll take that as a no," King replied.

Judge King announced the sentence: "The sentence of the court is that the defendant is committed to the State Department of Corrections for a term of thirty years. He would be given a credit for time served since October 7, 2004."

"The hearing is adjourned."

A motive for the murder was not given in court.

Crystal Owen, staff writer for the *Item*, caught up with Attorney Brooks after the plea. Brooks said, "In light of everything and the evidence, we came to an understanding."

Solicitor Jackson commented, "I am very satisfied with the way the case ended."

Joyce's brother, Anthony, still resides in Sumter. In conversation with him in August 2008, he shared some memories:

> *Joyce and I grew up in the same neighborhood about four or five blocks from where the Macks lived. We knew the Mack boys and their sister, but I wouldn't say we were close friends. The Mack boys would take chances and do things, you know like boys do. I used to go fishing with their daddy. He just couldn't believe Tony had done this to Joyce. It has been hard for him. Mr. Mack is a good man. At the time of Joyce's murder, I worked in a party shop near the area where Joyce lived. Tony would come by the shop sometimes and drink a beer and talk. After Joyce's murder, he still came by, but he never acted any different. I never gave a thought to Tony doing this.*

Anthony said he also knew Henry Mack Singletary as a kid and was surprised when he was arrested first for Joyce's murder. "It's really been hard for me. I never got closure, even when Tony Mack was arrested, but over the years, I have gotten stronger, and I can talk about it a little easier now."

UNSOLVED MURDER OF GWENDOLYN ELAINE FOGLE

Walterboro, South Carolina, 1978

On Saturday, May 27, 1978, seven months into my career as a special agent/forensic photographer with the South Carolina Law Enforcement Division, twenty-six-year-old Gwendolyn Elaine Fogle was brutally attacked and murdered in Walterboro, South Carolina.

Walterboro is a small Lowcountry town filled with heritage and overflowing with southern hospitality and charm. The friendly, down-home atmosphere captivates visitors as well as all who have made it their home.

Residents of Walterboro would say about Elaine's murder, "Things like this just don't happen in a town like ours. You hear about it happening somewhere else, but not here."

But it did happen there, and the haunting lingers. It is still unsolved.

Elaine's roommate, Nancy Hooker, and Nancy's friend, Billy O'Bryant, worked at the J.P. Stevens Company in Walterboro. On Saturday, May 27, 1978, they had attended an AMWAY Products Fair in Conway, South Carolina, which is 150 miles away. They returned to Walterboro about 1:45 a.m. Sunday morning.

The silence and peacefulness of the town in the early morning was a welcome feeling as Nancy and Billy pulled into Nancy and Elaine's driveway at 210 South Lemacks Street. They walked onto the front porch and noticed the light on inside the house. They both thought it unusual for Elaine to still be up that late. Using Nancy's key, Billy unlocked the

Gwendolyn Elaine Fogle. *Courtesy of Eolean Fogle Hughes.*

door and they walked into a grisly, shocking scene. Elaine was lying on her back on the floor close to the front door. She was covered with blood, unconscious and partially nude. Both became hysterical, and they immediately rushed to the Walterboro Police Department, which was only about a mile away.

Still badly shaken, they told police that they could not tell if Elaine was dead or alive when they found her, but it appeared that she had been "horribly assaulted and possibly raped." Upon questioning, they said they had noticed that Elaine had been very quiet the past few weeks, like something might be bothering her, but she never talked to them about it.

Walterboro Police officers responded immediately to the Lemacks Street address and, upon arrival, checked Elaine's pulse but found none. EMS arrived at the home shortly thereafter and checked Elaine for any vital signs. There were none. Colleton County pathologist Dr. Frank Trefney and Colleton County coroner P.J. Maxey arrived at the scene. Preliminary examination showed that Elaine's death was caused by severe head injuries and strangulation.

The Walterboro Police Department called for assistance from the Colleton County Sheriff's Office and the South Carolina Law Enforcement Division (SLED) in Columbia, South Carolina. The SLED crime scene team arrived and assisted with photographing and processing the scene for evidence. The evidence was transported to the SLED forensics lab for further analysis. In the photography lab, I processed and printed the photographs of the crime

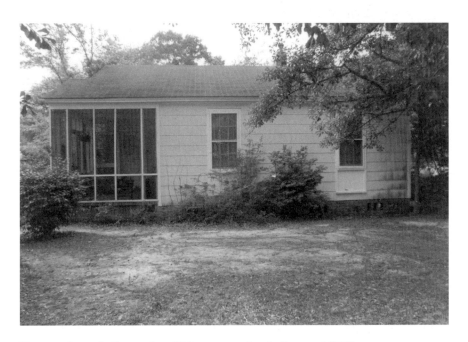

House on Lemacks Street where Elaine was murdered. *Courtesy of SLED.*

scene and photographed pertinent evidence from the scene using specialized equipment and procedures to further assist the crime scene team with their investigation.

The SLED Bloodhound Team was also called in from Columbia, but because of the time that had elapsed since the attack and the number of people who were around the scene, the bloodhounds were unable to be of any assistance.

Investigation revealed that on Saturday night, May 27, Elaine visited with some friends, arriving at their home about 6:45 p.m. and leaving about 11:15 p.m. to return to her residence. She told them that she was going to Orangeburg, which is about fifty miles away, the next morning for her mother's birthday. It was also established that Elaine had stopped at a Zippy Mart convenience store on South Jefferies Boulevard (Highway 15). She left the Zippy Mart about 11:20 p.m.

Crime scene investigators found that the killer(s) entered the home through a rear window by breaking out the glass and forcing the window up. It appeared that they had tried three other windows before getting one open. All of the windows had been nailed down because Elaine's home had been broken into approximately a year before. Police believed that the killer(s) were inside the house when Elaine arrived home that night about 11:30 p.m., and when she went in the front door and came upon the intruder(s) she tried to run back out the front door and was brutally attacked and beaten to death. Elaine's jeans were found on the roof of the back porch, so it appeared that the killer(s) left the house by the back door and threw her jeans on the roof upon exiting the house. Her car was still parked in her yard, but her keys were missing.

Elaine was a lab technologist for Dr. Joseph Flowers at the Walterboro Medical Center. Elaine had a key to Dr. Flowers's office on her key ring. As soon as Dr. Flowers found out about her keys being missing, he changed the locks on his office.

Elaine's older sister, Eolean, and her husband, Larry, lived in Whitmire, South Carolina. She and Larry were also planning to go to Orangeburg on Sunday to be with Elaine for her mom's birthday. Eolean got off work about twelve o'clock that Saturday night. When she got home, Larry told her, "I've got a strange feeling, and I feel like we need to go on down to your Mama and Daddy's tonight." Eolean agreed, so they packed up and went to Orangeburg. They visited for a little while, and then Larry and Mr. Fogle

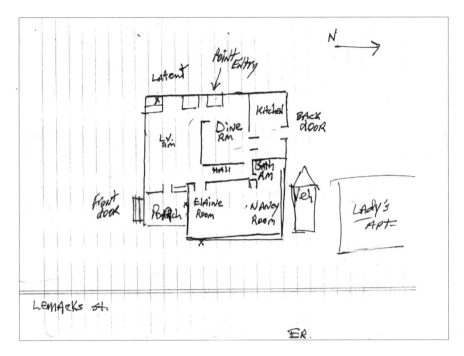

Crime scene sketch. *Courtesy of SLED.*

went to bed. Eolean and her mom sat around the kitchen table and talked until about 3:00 a.m. They had only been in bed about thirty minutes when Mr. and Mrs. Fogle were awakened by a knock on their bedroom window and a voice calling out, "Myrtis, it's Miriam. I need you to come to the front door." Miriam was Elaine's mom's sister.

The Walterboro Police Department had contacted the Orangeburg Police and asked for their assistance in informing the family about Elaine's murder. Officer Gene Brant with the Orangeburg Police Department was in the room when the call came in. He said that he was a friend of the family and a neighbor of Elaine's Aunt Miriam and Uncle Jimmy, and he would go. He went by Miriam and Jimmy's first and informed them of the situation. Miriam called their pastor and asked him to go with them to tell Elaine's parents.

After hearing the news, shocked and distraught, Elaine's mother said, "My God, my daughter was murdered on my birthday." Consoling themselves as best they could, they contacted some family members with the news, and Eolean, Larry and Mr. and Mrs. Fogle went to Walterboro to meet with the police.

Police officers told the family that Elaine appeared to have been beaten to death with a metal fire poker and that she had put up a heck of a fight during the struggle. Mr. Fogle got very upset when he heard about the fire poker. He had given it to Elaine.

Through dental records and fingerprints, the body was positively identified as Gwendolyn Elaine Fogle. Elaine's autopsy was performed by pathologist Dr. Frank Trefney at the Colleton Regional Hospital the following morning. The autopsy confirmed that she had been raped. The cause of death was asphyxiation due to a metal fire poker about her neck. The manner of death was homicide. Semen specimens and fingernail scrapings were collected from Elaine's body for further analysis. Additional findings showed extensive injuries to her head and body caused by a blunt instrument and that she had fought and struggled with her assailant(s), which would have possibly inflicted scratches, cuts or bruises to their bodies.

Investigator Ken Davis asked the media to let the public know that anyone observing someone who had questionable marks or bruising anywhere on his body or having any helpful information should contact the Walterboro Police Department, the Colleton County Sheriff's Department or the South Carolina Law Enforcement Division.

Davis also had them publish that a Walterboro resident had offered a $1,000 reward to anyone furnishing information that would lead to the arrest and conviction of Elaine's assailant, but encouraged readers to keep the main purpose at heart: to get a dangerous person off the street and get justice for Elaine. Fear shrouded the normally quiet town.

Additional officers were reassigned to work on the case. They began interviewing Elaine's acquaintances, boyfriends, close friends and anyone who could be a person of interest.

Elaine had moved from Orangeburg, South Carolina, in 1972 and worked at Colleton Regional Hospital in Walterboro. She later took the position with Dr. Flowers. Dr. Flowers commented to associate editor Bob Novit of the *Press and Standard*, "I am deeply distraught over Elaine's murder. It is very difficult for me to accept. Elaine was a hardworking, diligent girl. She would go out of her way to help anyone."

Mr. Novit also reported the feelings of some of Elaine's friends:

She seemed lonely when she first moved here but gradually became a real part of the community. She had started getting out more with friends. She

especially enjoyed working with children, taking them to games and teaching Sunday school…She was a cute kind of shy, and had the biggest heart. I never heard her say anything unkind about anybody…Elaine had recently started attending night classes at Baptist College in Charleston, South Carolina, pursuing a college degree. She had also completed some local art courses. One of her dreams was to become an accomplished artist. She was starting to have a lot going for her.

Elaine's funeral was held on Tuesday, May 30, at Thompson Funeral Home Chapel in Orangeburg. One of the directors found a single pink rose on his desk with a note that read, "This is for Elaine." The note was not signed.

With the case constantly active, the media could only release information to the public as it became available to them from authorized officials so as not to disclose any leads that might jeopardize the investigation. There were always the rumors that periodically popped up in the area that a suspect had been caught, but that's all they were—rumors.

After more than four months, the *Press and Standard* reported that Elaine's murder still remained a mystery but was being actively pursued every day. More than one hundred persons had been interviewed, some as suspects, some with possible helpful information and some as persons who had been arrested for other crimes in the area. Nothing conclusive had been determined from the evidence, but it was still being analyzed by the South Carolina Law Enforcement Division and the Medical University of South Carolina. Investigators, family, friends and the concerned community held on to hope that the evidence and continuing investigation might soon provide a break in the case.

Friends of Elaine started an Elaine Fogle Scholarship for area high school students; $250 would be awarded annually to a graduate of any school in Colleton County to further their pursuit of an education in the allied health careers field. It was sponsored by the Colleton County Medical Auxiliary Persons.

Through the years, the case was never solved. New leads came. New leads went. Is it possible that sometime in the past or present the killer(s) have been interviewed? Are the killer(s) still alive or are they now dead? So many questions remain unanswered, but somewhere, somebody out there knows something.

People of the close-knit community, along with Elaine's family, continue to hold on to hope that one day, with the advancement of new forensic technology and the grace of God, Elaine's killer(s) will be brought to justice, and this will bring some peace to the family and community who have lived with this for most of their lives.

I never forgot this case. I wanted to find Elaine's family. In 2007, I located Elaine's sister, Eolean, and told her I planned to write Elaine's story. She was humbled and thankful to know that Elaine was still being remembered. She said, "I watch *Forensic Files* and *Cold Case* faithfully, and I see how old cases are being solved with all this new technology. I've prayed that this will be the answer to solving Elaine's murder, but I was told years ago that Elaine's case was closed."

It is assured that a "cold case" is never really closed, even after years and years. It brings hope to the seemingly forgotten, even more today since advanced forensic technology offers a new way to examine the original evidence.

Eolean shared her loving memories of growing up with Elaine, her sister, whose life was cut short by a senseless act of someone who still remains unknown:

Elaine was a tomboy growing up. She loved to ride her bike all over Orangeburg. We would go to the Edisto Gardens all the time. She was in a lot of church clubs at our church, the Palmetto Street Church of God. She loved children. She worked at a nursery with our mom for a while until she graduated from the Orangeburg Technical School in 1972. After graduation, she moved to Walterboro and started working at the Colleton Regional Hospital. She loved doing all kinds of things for her grandmother and aunts, uncles and cousins. Elaine loved to draw and paint and she had started taking some art courses. She painted pictures and gave them to all her aunts the Christmas before she was killed. We were all very close. She was always kind to people. When somebody didn't have a place to stay, she would let them stay with her. That is how Nancy was living with her. Elaine told me that she had asked Nancy to move and that wasn't like her to do that without a reason, but we never knew why. When they didn't find who killed Elaine, Mama went to Mary Green, a psychic in Columbia. I still have the tape she made. Mrs. Green said it had something to do with drugs, and it wasn't Elaine they wanted, but Elaine knew the person and that's why she was killed.

Elaine (left) and her sister, Eolean, as kids. *Courtesy of Eolean Fogle Hughes.*

Mr. and Mrs. Fogle, Elaine (left) and Eolean at Easter services. *Courtesy of Eolean Fogle Hughes.*

Elaine loved riding her bike all over Orangeburg. *Courtesy of Eolean Fogle Hughes.*

Mama took it to the police, but they said they didn't believe in that stuff. Mama also asked the police if maybe Elaine's story could be run on Unsolved Mysteries, *and they told her that wouldn't help. Elaine was very interested in crime solving. I know she would love the way crime solving has come along, and I believe if she was still alive she would be in the middle of it.*

She had just gotten engaged several weeks before she was killed. Her fiancé kept in touch with our family for a long time. He later married and had a daughter. He named his daughter Elaine.

Our daddy died two years after Elaine was murdered. I think he grieved himself to death. He was bothered every day of his life after Elaine was killed that he had given Elaine that fire poker. After Daddy

died, Mama lived alone in Orangeburg on Old St. Matthews Road. Thirteen years after Elaine's murder, in November 1991, when she was sixty-five years old, she was attacked by a black male in his twenties. Around midnight on a Friday night, Mama heard noises outside her house and got up to check if everything was all right. She looked out a window and saw the man in her yard. The man saw her at the window, and yelled, "Do you have a gun in there?" She told him "Yes," and he yelled back, "I've got one, too." Mama ran to the phone, but the man had cut the wires outside and the phone was dead. The man then kicked in the door and went inside and grabbed Mama. He started hitting Mama with his fists and a stick, threw her down on the floor and kept hitting her. Mama said he threatened to rape her, but she told him she had AIDS. With that he left her alone and went through the house and stole five dollars and some of Mama's costume jewelry. As he was leaving, he yelled at Mama, saying, "If you come out of this house, I'll be waiting in the yard and kill you." Mama stayed huddled in the house until around nine-thirty Saturday morning, when she went outside and flagged down her niece who was driving by. They called the Orangeburg Sheriff's Department for help. Mama's attacker was never found either. She would say over the years how she now knew some of the torture that Elaine suffered at the hands of her killer. Mama died in her sleep in 1999. The doctor said, "Looks like she just went to sleep and forgot to wake up." I felt she was finally at peace. Mama and Daddy never got over losing Elaine and her murder never being solved. They lived every day with hope that it would be solved, and they both died holding on to that hope. One thing that Elaine used to do still gives me chills every time I think about it. Elaine loved life so much and was so comfortable where she was in life. She would strut around the house and laugh and say, "When I die, I'm gonna make history." In a way she did, but not the way any of us would have ever imagined.

Author's Note

On May 29, 2008, my niece's husband's sister-in-law, Sherri Adams, and her eleven-year-old daughter, Amber, were in a tragic accident in Orangeburg, South Carolina. Amber was killed. Sherri was in a Columbia hospital with back injuries.

I had attended an Adams family picnic several years before and had met Sherri and her family. I wasn't sure if she would remember me, but I felt something pulling me to the hospital to visit Sherri. Her husband, Timmy, was in the hallway when I arrived. I asked if he remembered me, and he said, "Yes, you're Rhonda's [my niece] aunt…her dad's sister. You look just like him."

I asked if Sherri was up for a visitor. He said, "I think so. She's had a pretty good day, and she's sitting up."

I walked in and introduced myself. She said, "Oh yes, you're Rhonda's aunt. You worked for SLED, and you've written books about some of your cases."

I said, "Yes, I'm actually working on my third book now."

Immediately, she asked, "Have you ever thought about writing a story on an unsolved murder in Walterboro in 1978?"

Surprised, I said, "Oh my God, Elaine Fogle."

"Yes," she answered.

"That is one of the stories in this book, a case that has haunted me for thirty years. How do you know Elaine?"

At that point she was shaking. "She's my cousin," she said, and she pointed to a photo of her daughter, Amber, that she had in her room. "That's my Amber, and my family says she acts so much like Elaine. I know Elaine was murdered in May. Please don't tell me it was the twenty-ninth."

"No, I said, it was May twenty-seventh."

She called Timmy into the room and told him about my writing Elaine's story. "Isn't it odd that Rita was only in my room for about three minutes when we started talking about Elaine?"

He said, "You know, we have been thinking and thinking about some meaning coming out of our tragedy, and I think this is the answer. The family thought Elaine's case was closed and no one was thinking about her. Now we know she is still thought of, and maybe one day her case will be solved."

I stayed for hours afterward talking to Elaine's family as they visited Sherri. A family that I never knew was a part of Elaine Fogle…someone I never forgot.

Time passes. Cases go unsolved…but the victims are never forgotten.

—CBS *Cold Case*

BIBLIOGRAPHY

Acts and Joint Resolutions of the General Assembly of the State of South Carolina, 1974, no. 1109, Section 1-16-52.

Special Agent Diane Bodie (SLED agent/fingerprint examiner) in conversation with author, 2008.

Captain David Caldwell (SLED agent/behavioral science) in conversation with author, 2008.

Court of General Sessions. Court transcript: *The State of South Carolina v. Tony Mack*, October 2006.

Criminal Statutes of South Carolina 1894, vol. 21, Section 109.

Lieutenant Tom Darnell (SLED agent/fingerprint examiner) in conversation with author, 2008.

Special Agent Dan DeFreese (SLED agent/firearms examiner) in conversation with author, 2008.

Don Grindt (former SLED agent/fingerprint examiner) in conversation with author, 2008.

Captain Ira Jeffcoat (SLED agent/DNA) in conversation with author, 2008.

Special Agent David McClure (SLED agent/DNA) in conversation with author, 2008.

Lieutenant Ira Parnell (SLED agent/firearms examiner) in conversation with author, 2008.

SLED case file of victim Elaine Fogle (limited to segments previously released as public information).

SLED investigative case files. Victims: Mary Lee Stroman, William P. Stroman, Amos Bowers, Nancy Linett Amaker, Joyce Robinson.

South Carolina Archives and History. Court docket records: *The State of South Carolina v. Dwight West,* May 1956.

South Carolina Archives and History. Court docket records and trial transcript: *The State of South Carolina v. Samuel Wright Jr.,* May 1955.

South Carolina Supreme Court. Court transcript: *The State of South Carolina v. Jack Leland Allen,* March 1975.

Special Agent Valerie Williams (SLED agent/investigator) in conversation with author, 2008.

NEWSPAPERS
Calhoun Times
Columbia Record
Item
Press and Standard
State
Times and Democrat

WEBSITES
www.dna.gov
www.judicial.state.sc.us
https://sword.doc.state.sc.us/incarceratedInmateSearch/index.jsp

ABOUT THE AUTHOR

Lieutenant Rita Y. Shuler was supervisory special agent of the Forensic Photography Department with the South Carolina Law Enforcement Division (SLED) for twenty-four years. She interfaced with the attorney general's office, solicitors and investigators, providing photographic evidence assistance in the prosecution of thousands of criminal cases.

Her interest in photography started as a hobby at the age of nine with a Kodak brownie camera.

Before her career as forensic photographer, she worked in the medical field as a radiologic technologist for twelve years. Her interest in forensic science evolved when she X-rayed homicide victims to assist with criminal investigations.

Shuler received her specialized law enforcement photography training at the South Carolina Criminal Justice Academy in Columbia, South Carolina, and the FBI Academy in Quantico, Virginia.

Shuler holds a special love for South Carolina's coast and is a devoted crabber and runner. She resides in Irmo, South Carolina.

ALSO AVAILABLE

CAROLINA CRIMES

978-1-59629-166-9
192 pp., 9 × 6, $22.99

MURDER IN THE MIDLANDS

978-1-59629-250-5
160 pp., 9 × 6, $19.99

Visit us at
www.historypress.net